To
Lyle
and
Sarah

John Safer

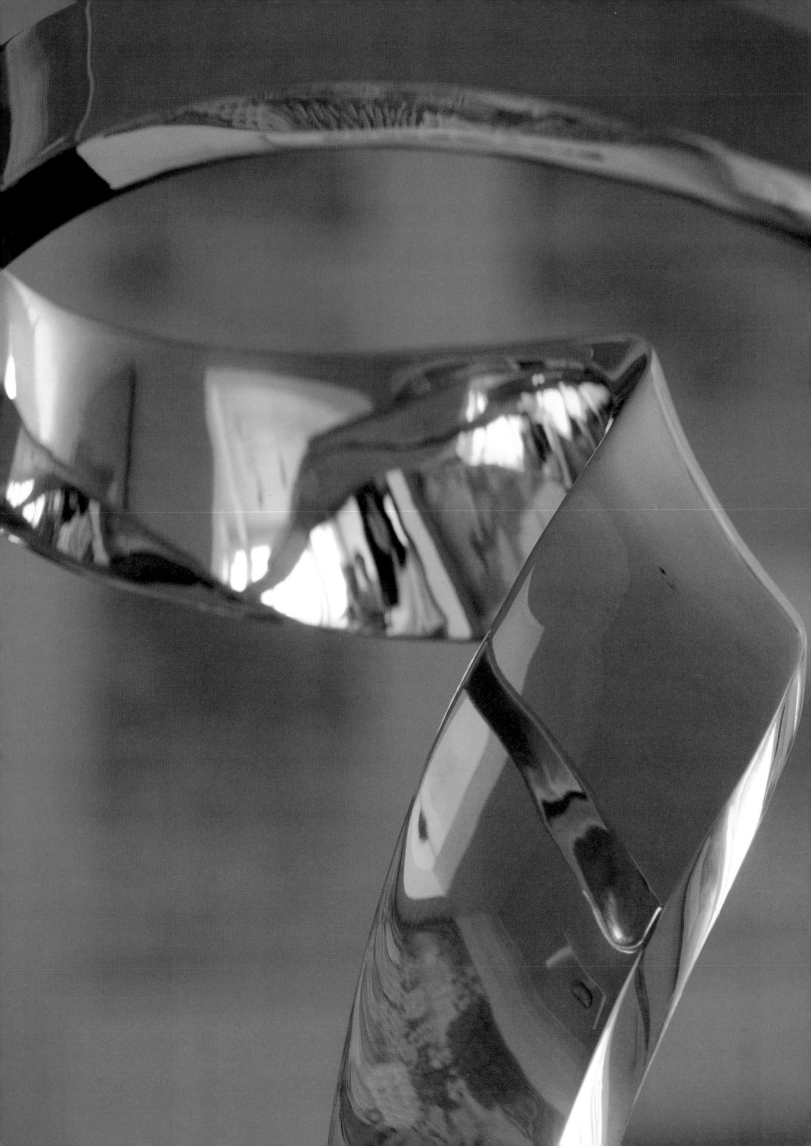

Art in Flight:
The Sculpture of John Safer

By WALTER J. BOYNE

Introduction by DOUGLAS LEWIS

Photographs by DAVID FINN

Hudson Hills Press • New York

First Edition

Illustrations and compilation ©1991 by Hudson Hills Press
Text © 1991 by Walter J. Boyne
Introduction © 1991 by Douglas Lewis
All rights reserved under International and Pan-American Copyright Conventions.
Published in the United States by Hudson Hills Press, Inc., Suite 1308, 230 Fifth Avenue,
New York, NY 10001-7704.

Distributed in the United States, its territories and possessions, Canada, Mexico, and
Central and South America by National Book Network, Inc.
Distributed in the United Kingdom and Eire by Shaunagh Heneage Distribution.
Distributed in Japan by Yohan (Western Publications Distribution Agency).

Editor and Publisher: Paul Anbinder

Proofreader: Lydia Edwards

Indexer: Karla J. Knight

Designer: John Morning

Composition: U.S. Lithograph, typographers

Manufactured in Japan by Toppan Printing Company

Library of Congress Cataloguing-in-Publication Data

Boyne, Walter J., 1929–
 Art in flight : the sculpture of John Safer / by Walter J. Boyne ;
 introduction by Douglas Lewis ; photographs by David Finn.
 p. cm.
 Includes bibliographical references (p.) and index.
 ISBN 1-55595-063-9 (alk. paper)
1. Safer, John—Criticism and interpretation. 2. Sculpture,
Abstract—United States. I. Safer, John II. Finn, David, 1921–
. III. Title.
NB237.S18B68 1991 91-3272
730'.92—dc20 CIP

Contents

Colorplates

*SUNDIAL 1991 Polished and patinated bronze on brown granite base, 14×14×6 inches. Collection of
Lyford Cay Club, Nassau, Bahamas.*

Reflections of the Artist

The thoughts underlying my art are positive and straightforward. Because basic tenets rest on faith rather than logic, I start with a few credos. I believe life is good. I believe that people should live together in harmony, and that they should respect each other's rights and treat one another with kindness. Therefore, I think civilization and a government under law are necessary.

In my sculpture, I try to show the beauty of life. I try to show that all of us are related, one to another, and to the world and universe in which we exist. I try to show the beauty and the essence of those relationships.

When I create a new work, I do much of my thinking with my hands. Even when, as sometimes happens, the entire design of a new piece comes to me in a flash, the position of each line and shape is to some extent dictated by the surrounding lines and shapes. Likewise, the materials and the textures, and sometimes the name, seem to grow organically from the original concept.

Since art transcends all language barriers, as well as time and space, it is my goal—perhaps more a hope—that people now and in times to come will sense from my creations the concepts that brought them into being, and somehow feel closer to each other and to the world in which we must all try to live.

John Safer

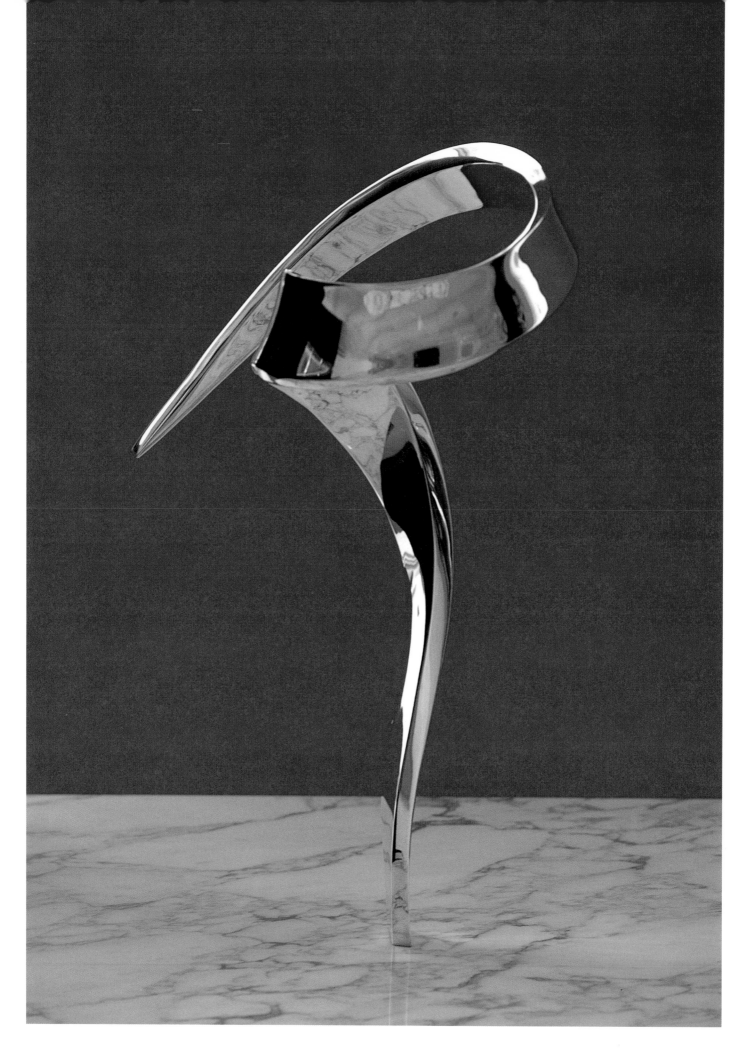

LINE OF FLIGHT 1985 *Polished bronze on white marble base, 27×18×24 inches.* *Collection of Lyford Cay Club,*

Nassau, Bahamas.

A Note from the Photographer

The camera lens enables one to discover islands of beauty overlooked by the naked eye in the details of John Safer's sculptures. It is a revelation to see in these simple forms complexities suggesting hitherto unknown dimensions.

In those sculptures that have reflecting surfaces, the camera eye is especially stimulated by what seem to be secret realms of light and color. They are secret in the sense that we find them for ourselves. They are not *there* in the sculptures; they come alive for an instant as we move to catch changing patterns in the shiny surfaces of the curving forms. The sculptures provide the magical mirror, but the vision is ours as we peer into those brilliant pools of light and interact with the flow of dazzling shapes and colors.

With John Safer's work one tries to make the most of these evolving images. His sculptures capture the space around them, reaching out in soaring forms, attracting rays of light from beyond like the curved lens of a telescope, and producing mixtures of colors and shapes unlike any that one has seen before.

Even those works that do not have reflecting surfaces seem to have the power to project the mind into space. There, the forms themselves carry the eye along paths that end in the air and leave us suspended. The sculptural experiences in these works echo, in their own way, the creative inventiveness of the works in transparent Plexiglas and polished steel.

There is a consistent pattern in all of Safer's work. He loves forms that bend space in original ways. And each sculpture is developed around a single conception that is

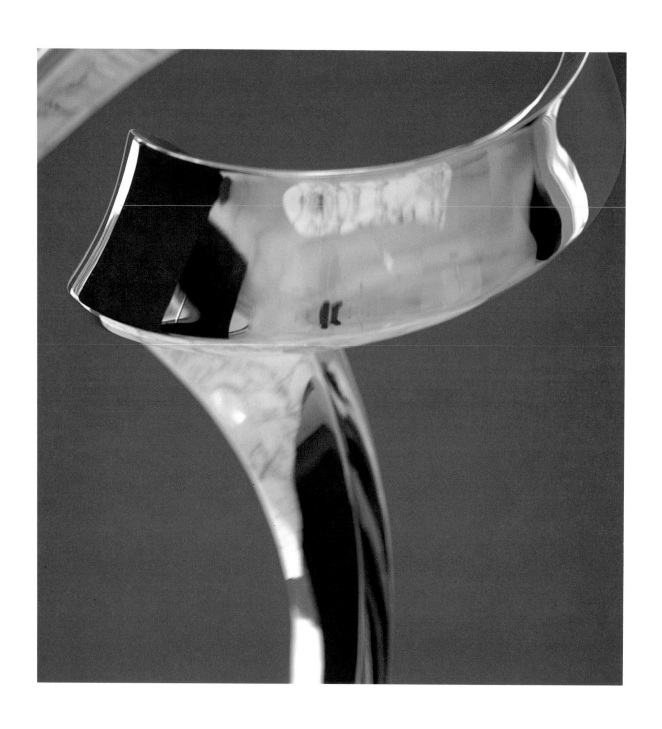

LINE OF FLIGHT (details)

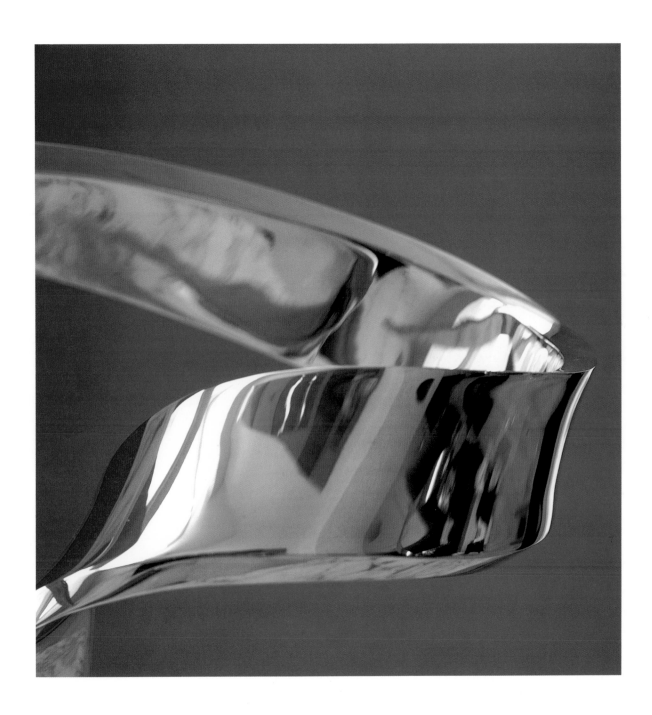

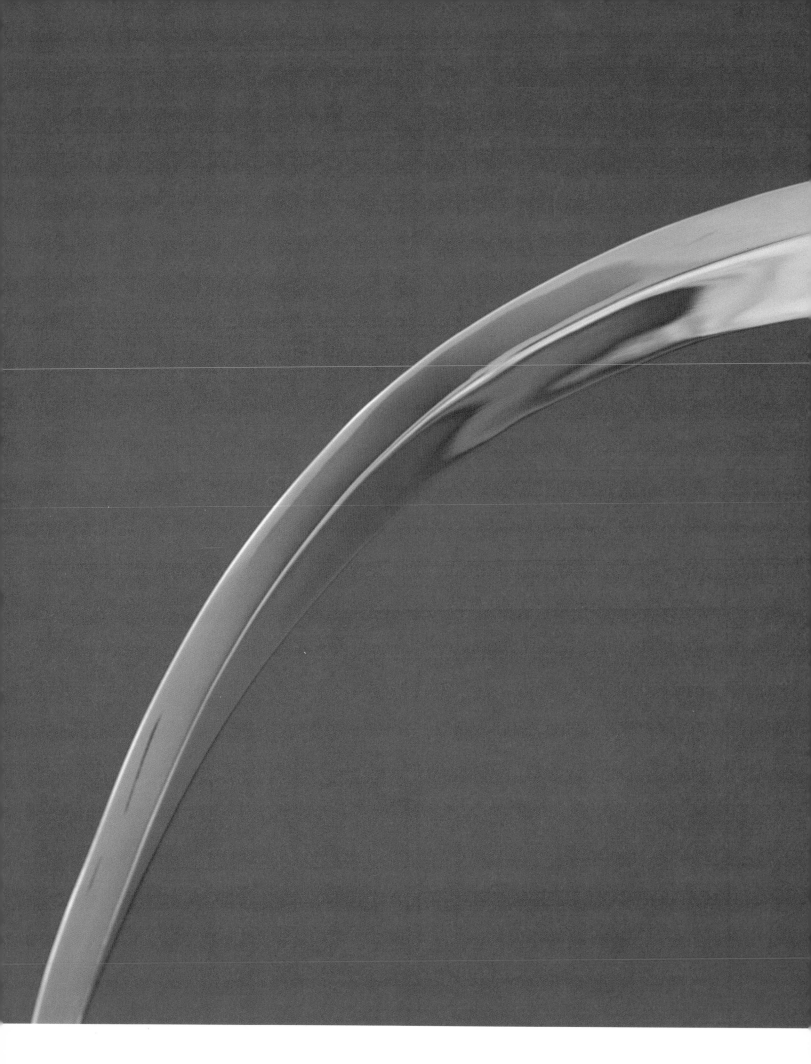

LINE OF FLIGHT (detail)

carefully worked out. Every part is related to that central idea. One can look at the work from any angle and be aware of a creative concept that invites the viewer to explore its many manifestations. I have found this invitation irresistible.

That is why photographing John Safer's sculptures over a period of several years has been an adventure for me. Each work presented a distinctive kind of imagery that stimulated my camera eye. And almost always I found such a wide variety of harmonies that I ended my photographic sessions with the feeling that I should have used a few more rolls of my favorite film and tried some other lenses to do full justice to each piece. For a photographer of sculpture, to be left with this nagging sense of incompleteness is perhaps the best measure of the limitless qualities in the work.

I know that the remarkable images I found in John Safer's sculptures have added a special richness to my vision of the space in which we live. I hope that my photographs will provide others with an appreciation of their endless fascination.

David Finn

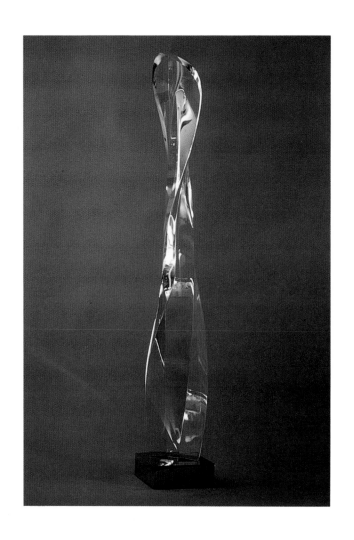

FLAMBERGE 1971 *Clear Lucite on polished brass base, 30×4×4 inches.* Collection of Mrs. S. P. Fagadau, Dallas.

Introduction

This book celebrates the myriad images generated by John Safer's sculpture. The critical eye of the camera, applied to Safer's oeuvre, has produced—for me—an altogether unexpected series of revelations. Safer's works had heretofore always been photographed as whole forms, complete with bases, and often even with pedestals and full contexts. It is quite remarkable to note, in retrospect, the degree to which this essentially archival vision had simplified his sculptural shapes to silhouettes, and turned his crystalline palette toward a more monochromatic vision. David Finn's extraordinary skill in transmitting to two dimensions the physical corporeality of sculpture, with all its ambient power and chromatic intensity, has rarely produced a more impressive result than in his radically revisionist view of John Safer's work. A telling concentration on details, for example, unerringly focuses our attention on those crucial contours, those innate transitions of form that epiphanize the entire structure of an object: we suddenly learn far more than I had thought possible about the essential integuments, the balance of tensions through the comprehensible *ponderation* of Safer's sculpture.

Above all, David Finn's inspired eye shows us unsuspected kaleidoscopes of color, especially on the chromatically saturated surfaces of Safer's recent work. The sculptor's consistent direction toward an increasingly volumetric density and presence, as well as an ever-heightened surface reflectivity and brilliance, stands revealed as the creation of a magical palette for the manipulation of circumambient light and color. For an artist first motivated by transparent plastic, the sheer intensity of this spatial and coloristic achievement is astonish-

ing. In these profoundly evocative photographs John Safer emerges as a sculptor of radiant incandescences of color, suffused over forms of beguiling purity, that are yet articulated with a deeply satisfying richness of invention.

John Safer's first publicly exhibited three-dimensional work, *Chess Set*, dates from 1964, and since 1969 the showings of his recent sculptures have followed at almost annual intervals. In more than thirty years of artistic activity he has produced well over one hundred different designs, many of which have been revisited in varying dimensions and alternative media. I have followed his unusually active career with close interest, and about halfway through its course, in June 1978, I summarized my impressions of Safer's work in an article published in *Arts* magazine. The present possibility of assessing a repertory almost twice as large, and especially the opportunity of perceiving it more integrally within the history of modern sculpture, offers a range of new perspectives on the artist and his achievement.

Throughout his first decade and a half as a sculptor (1959–73) Safer worked exclusively in one medium, clear or colored acrylic plastic. Early in his career, critics discerned a polarity between what they called his "Constructivist" (or rectilinear) compositions and his "organic" (or curvilinear) forms. It seems worth remembering, however, that his acrylic materials themselves were principally available in two forms: in rods, of round section, and flat sheets or blocks of varying thickness. Safer's early constructions with the latter types of material—such as *Interplay I* (1968), *Cube on Cube* (1969) and the *Multicubes* (1969), or *Symbol I* (1970)—placed him directly in the tradition of Naum Gabo, Antoine Pevsner, and the early-twentieth-century masters of de Stijl, while his early pieces made of bent and twisted round-section rods—dozens of variations of the Twist series, from the mid-1960s, or, a decade later, his *Laocoön Revisited* (1975)—tied him just as firmly to the curvilinear, biomorphic tradition that his reviewers compared with Futurism, Constantin Brancusi, or Jean Arp. The point, in retrospect, is that Safer's earliest work was understandably derivative; but in my view it gains interest (as well as promise for the future) insofar as it appropriately reflects the nature of his materials, even more clearly than it follows a perhaps superficial dichotomy in classic modern sculpture. I believe the most original work of Safer's early years—in a sense bridging this perceived polarity—was his six-foot-high *Chandelle* (1969), whose large emblematic flame was formed from a single artfully warped plane of delicately contoured black acrylic.

1970 was a pivotal year in Safer's development, for it inaugurated two major innovations whose combined potential is still being explored in his best work. The more subtle of these was a carefully calibrated introduction of opacity in his plastics; the more obvious was a bold, three-dimensional shaping of tall, hard-edged blocks of Lucite, through heat warping and reductive carving, into sinuous, flamelike columns of curvilinear silhouette. *Probe, Stasis,*

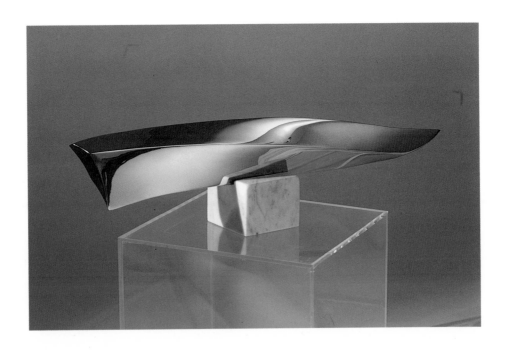

and *Crystal*, all of 1970, are the clear acrylic pioneers of this signature motif, Safer's most characteristic invention; the first incorporates a platform element of black acrylic (recalling the clear and dark-colored alternation of *Chess Set*, certain of the *Twist* pieces, or *Chandelle*), while all three are supported on cubic bases of frosted clear plastic, in a conscious differentiation of surface and texture that became a crucial forerunner of later work. A still subtler manipulation of opacity was achieved in the following year by the introduction of translucent smoky acrylic, accomplished in varying densities in *Symbol II* in the Constructivist mode, and still more suggestively in the biomorphic abstraction of *Janine* (1971). At this same moment opaque, frosted acrylic was used as a medium for the principal formal element of *Bellegarde* (1971), rather than merely as such an element's base (which in this case was black); and the contemporaneous *Anaitis* for the first time offered a six-foot image in solid black acrylic.

I have dwelt at some length on Safer's remarkably rapid and coherent introduction, in 1970–71, of varying degrees of opacity into his hitherto overwhelmingly clear-plastic formal vocabulary, because I have lately come to see this element as a key to the most interest-

PISCES III 1975 *Polished bronze on white marble base, 6×20×4 inches.* *Collection of Mr. Caio Machado, Rio de Janeiro.*

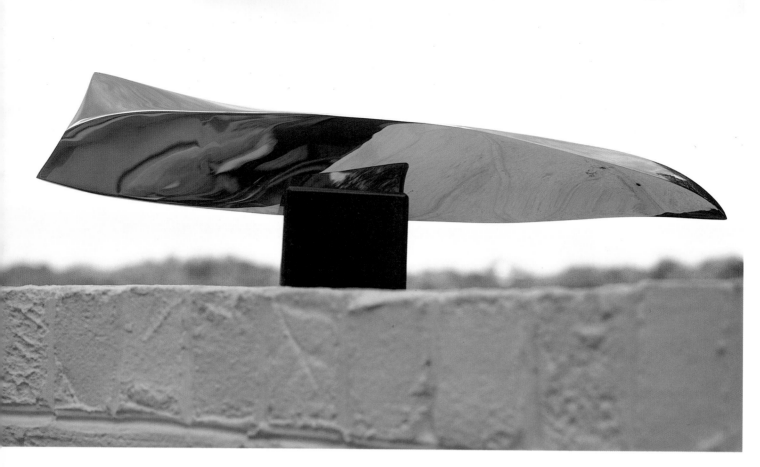

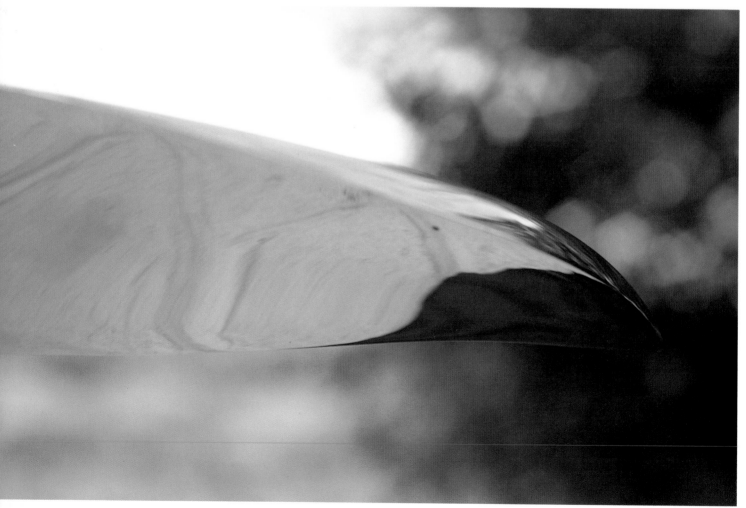

PISCES IV (with details) 1978 *Polished steel on black granite base, 7×23×4 inches.* 2 0

Collection of Mr. Adam Lindgren, Washington, D.C.

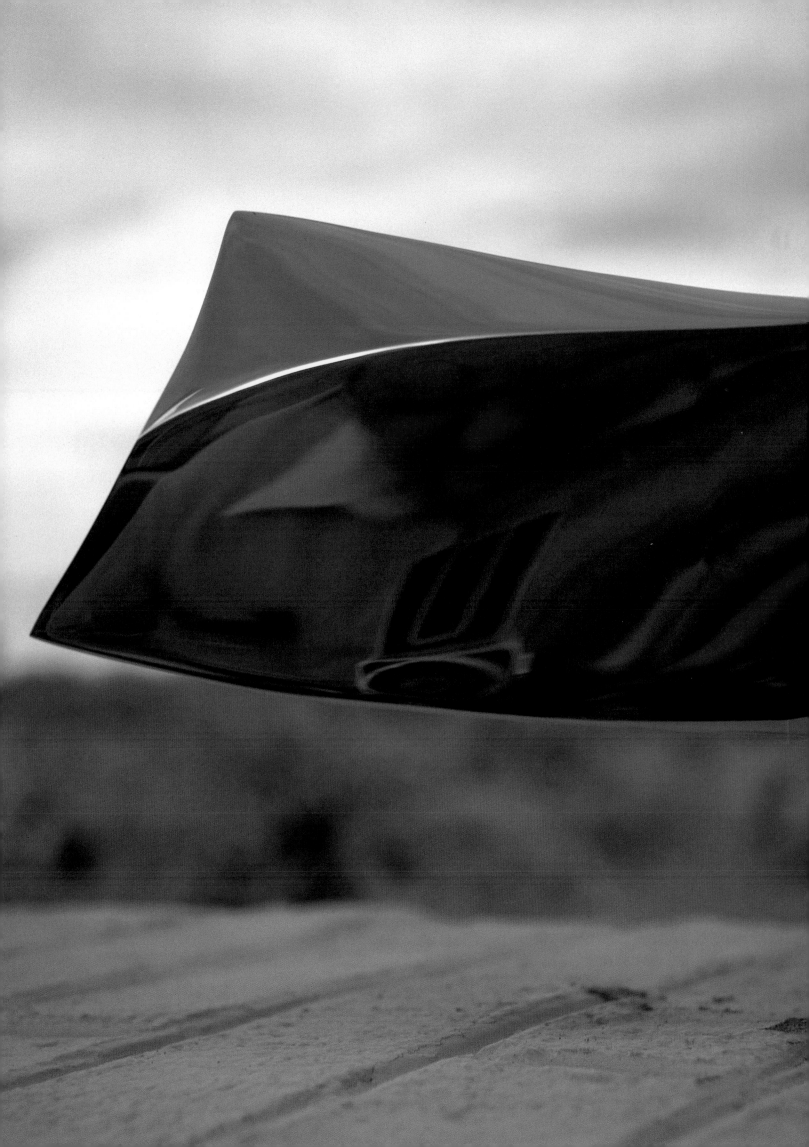

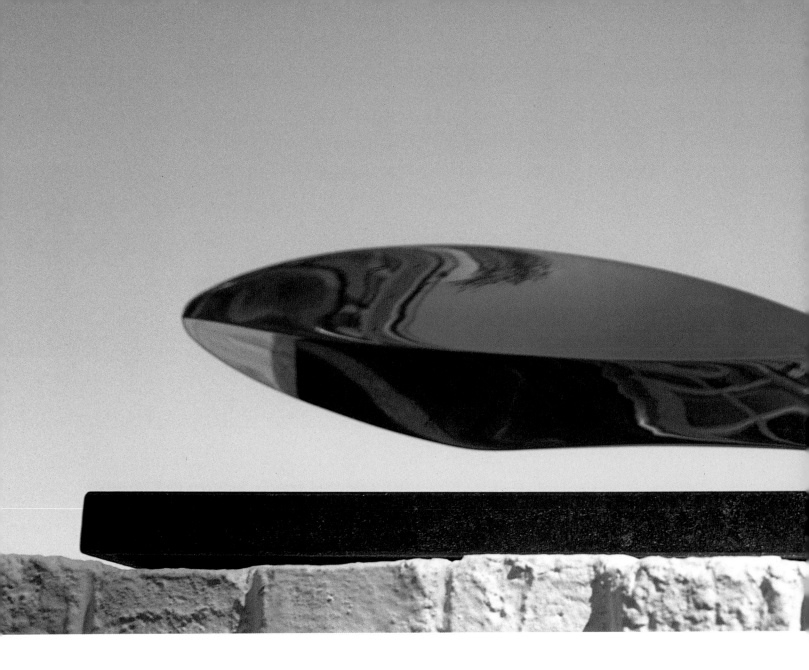

ing direction that I perceive in his sculptural development. At the same time as he began this
modification of his basic acrylic medium, he made the still more significant innovation of
introducing bases of completely opaque, reflective metal—in brass, for the 1971 sculptures
Janine, Étarre, and *Flamberge,* which I had nominated in my earlier article as the masterpiece of
his columnar-crystalline genre, or in polished aluminum, for the base of *Cockaigne* in the same year.

It seems to me significant that Safer first approached the medium of metal
entirely in rectilinear terms and—initially—exclusively for the secondary elements of bases.
He first overcame this latter restriction with three immediately successive works whose
iconographic components, as well as their uniform bases, are entirely of metal. The pioneers
in this breakthrough are a 1973 three-piece miniature maquette called *Interplay II*—later
retitled *Structure*—with two corner-balanced cubes flanking a rectangular monolith, all of
brush-finished brass; *Terminus,* which in 1972 used the same material to evoke the Roman god
of boundaries, with its planar, "semaphore" arms; and the 1974 *Bauhaus Remembered,* which

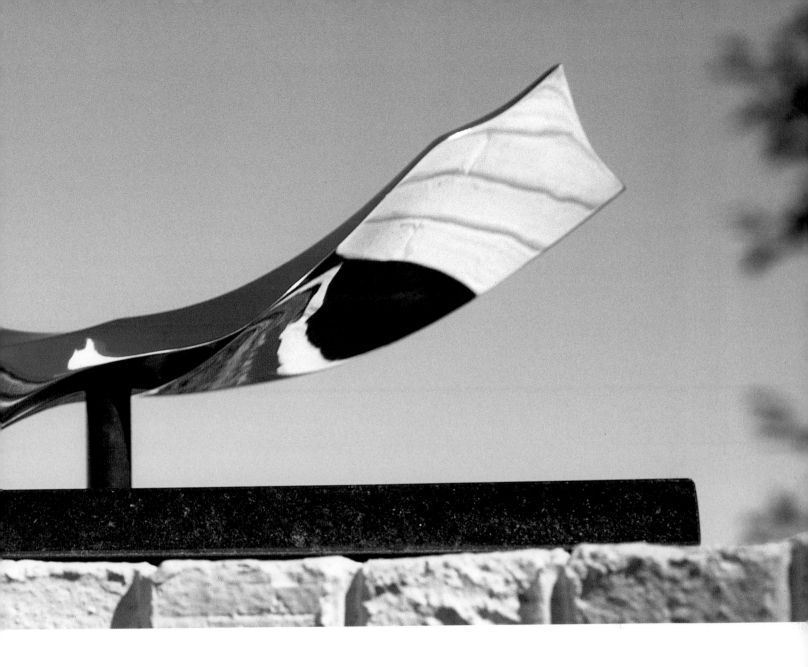

took the fateful step of introducing a fully reflective mirrorlike finish, by the chrome plating of highly polished brass. All three of these works (together with *Time Frame* [1972], in black acrylic) are resolutely hard edge and rectilinear, yet they are effectively the last such uncompromisingly Constructivist works in Safer's oeuvre. (There are eventual or partial exceptions, such as *Déjà Vu* and *Swing* in 1977, *Shaman*, 1979, *Four Space*, 1980, and *Timepiece*, 1985; but their relative rarity only serves to underscore this point.)

I see it as diagnostic of Safer's basic motivation as a sculptor that as soon as he achieved fully reflective opacity in a polished-metal surface—as soon, in other words, as he had wedded his early acrylic "light-encapsulating" style to the classic medium of metal—he turned for the remainder of his career to the virtually exclusive exploration of his signature

ARIEL II 1983 *Polished bronze on black granite base, 8×20×10 inches.* Collection of Mr. and Mrs. Florenz Ourisman, Palm Beach, Florida.

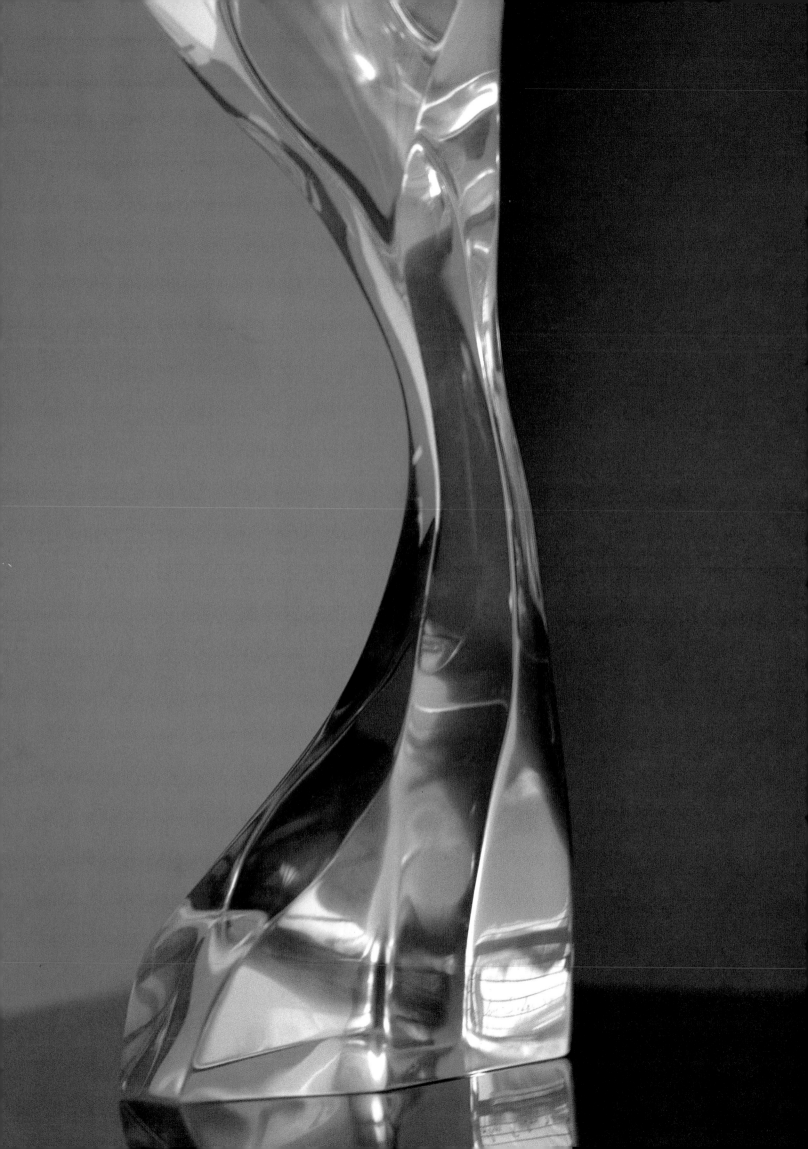

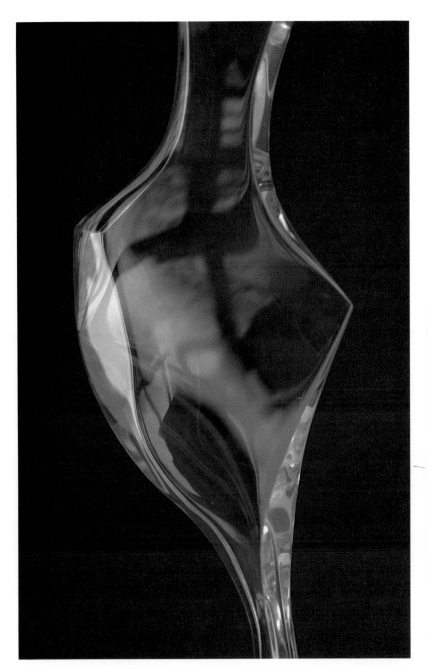
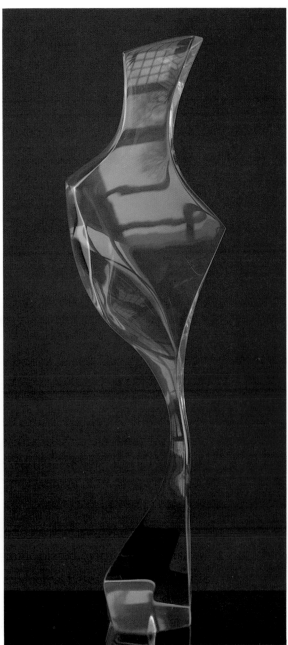

biomorphic images, often still in acrylic (though from this point almost always tinted), but increasingly in the more challenging and supremely rewarding surfaces of bronze, chrome, brass, and steel. This departure is beautifully heralded in the successive golden and silvery variants of one of his most compelling shapes—*Pisces II* (1974) and *Pisces IV* (1975) in reflectively polished bronze, *Pisces III* (1974) brilliantly chrome plated, with a later version (1978) in polished steel. These forms glide in fluid asymmetry across bases of another classic (and equally opaque) sculptural material, sinuously veined white marble.

SOPHISTICATED LADY (with details) 1978 *Clear Lucite, 17×5×6 inches. Collection of the artist, Washington, D.C.*

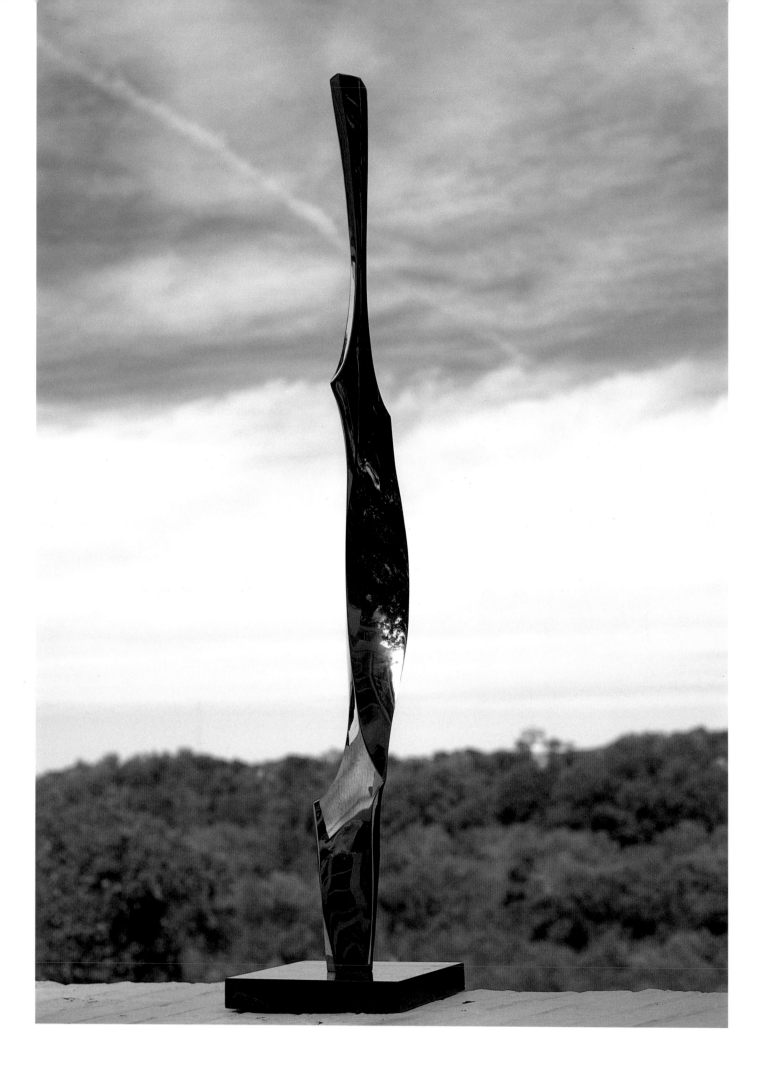

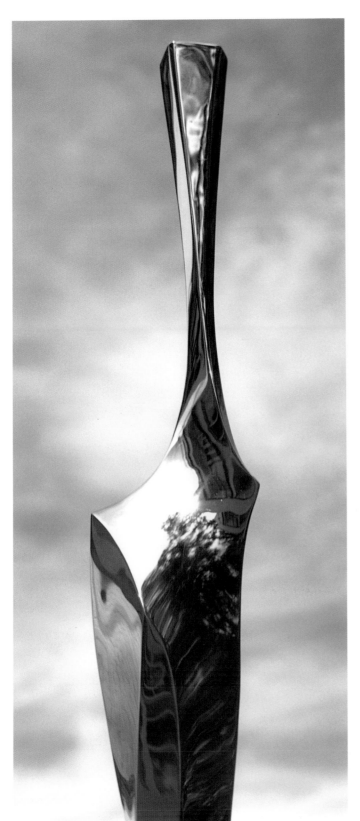
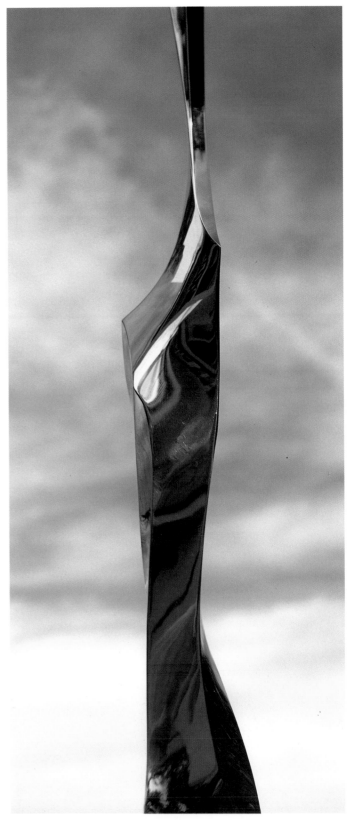

NULL SPACE III (with details) 1979 *Polished steel on black granite base, 41×8×8 inches.* *Collection of the artist,*
Washington, D.C.

2 7

The latest and for me the most exciting phase of Safer's sculpture was inaugurated, in the mid-1970s, by a breathtaking series of angularly carved yet hauntingly organic forms. *Null Space I* and *Samurai* in 1974; *Logos* in 1976; *Cinquantaine, Clovis,* and especially *Ariel* in 1977 are, in my view, among Safer's most compelling masterpieces. Significantly for my thesis of increasing sculptural quality through opacity of surface, as well as through the artist's progressive recourse to classic materials, only two of these masterworks are in Safer's original medium of clear acrylic. The other four are translucently tinted, while the first *Null Space* and *Ariel* almost immediately generated metal descendants: *Ariel II* (1983) in a spectacular distillation of polished bronze, and *Null Space II* and *Null Space III* (1979) in the seductive surfaces of polished steel and antique-patinated bronze. (This last, of course, is a consummately historical technique that was also exploited in Safer's retrospectively reminiscent multiple-piece maquettes of *Judgment, Linkage,* and *Siege* of 1977–81.)

The evocative two-piece maquette of *Tango* (1978) is Safer's earliest dated work in polished steel, the material I would identify as affording a perfect resolution of his own "light-encapsulating" style with the three-dimensional mass and density of traditional sculptural form. Gerald Nordland saw the superb steel *Quest* of 1979 as "a culmination, . . . the triumph of his work until that time, . . .an outstanding piece of twentieth-century sculpture."* It precisely transmutes the sparkling, curvilinear columns of Safer's early acrylic forms into even more gemlike reflectivity, through the medium (as a comment on modern technology) of an even more contemporary material. In the same sense, the angular, anthropomorphic contours of *Soliloquy* were first invented in acrylic (1978), then recast in polished steel (1980) and eventually twinned, in shimmering metal, to create *Echo* (1983). Even more grandly, *Interplay III* (the only one of Safer's serial titles to be applied in each instance to a radically different design) was initially conceived in smoky acrylic (1979, fifty-four inches high), then cast in polished bronze in the mid-1980s; in 1987 it was expanded to monumental scale in reflective steel, as *Interplay IV*. Brilliantly burnished bronze and steel have indeed become almost the exclusive media of Safer's most recent decade—as epitomized respectively by paradigms such as *Line of Flight* (1985) and *Pathway I* (1988).

John Safer's sculptures are intriguing and satisfying of themselves, but the intrigue deepens when one considers the extraordinary range of their titles. Although contemporary abstraction has to some degree made an orphan of artistic subject matter and its iconography (as often downplayed by artists as it is neglected by critics), Safer's verbal guideposts to his own visual oeuvre are striking exceptions. They are multilingual and multicultural,

*Gerald Nordland, "Introduction," in Frank Getlein, *John Safer* (Washington, D.C.: Joseph J. Binns, 1982), 2.

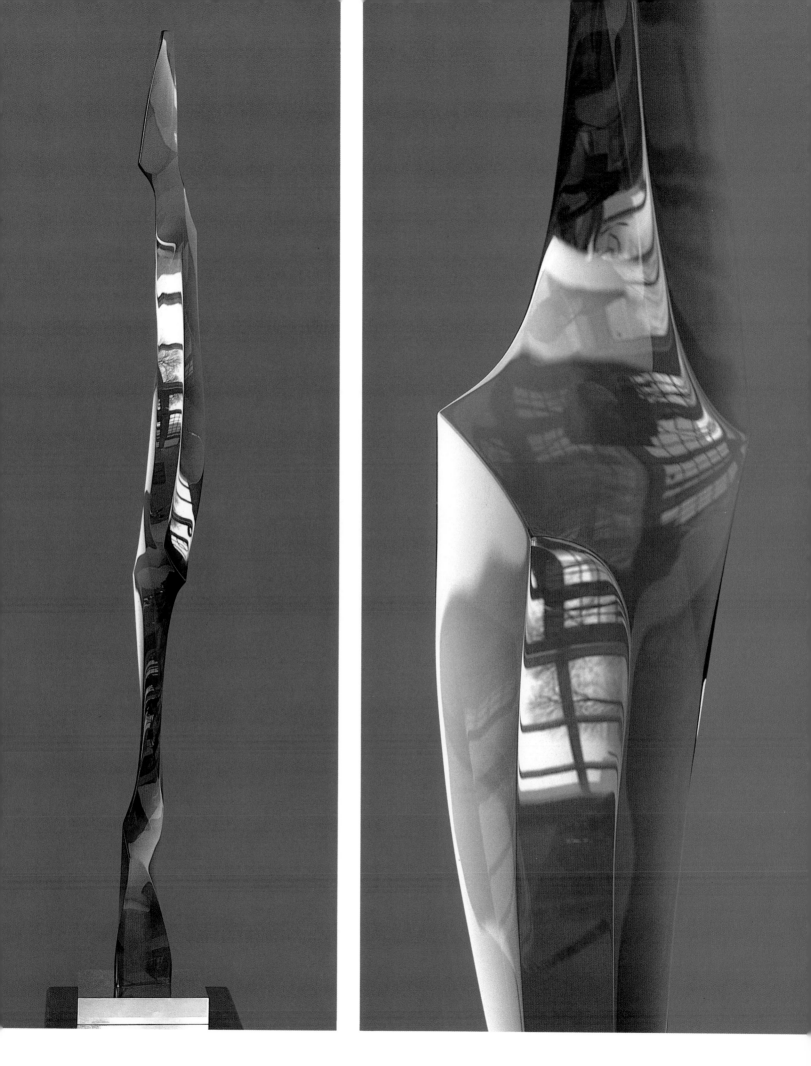

SAMURAI (with detail) 1974 *Brown Lucite on polished brass base, 63×8×8 inches.* *Collection of the artist,*

Washington, D.C.

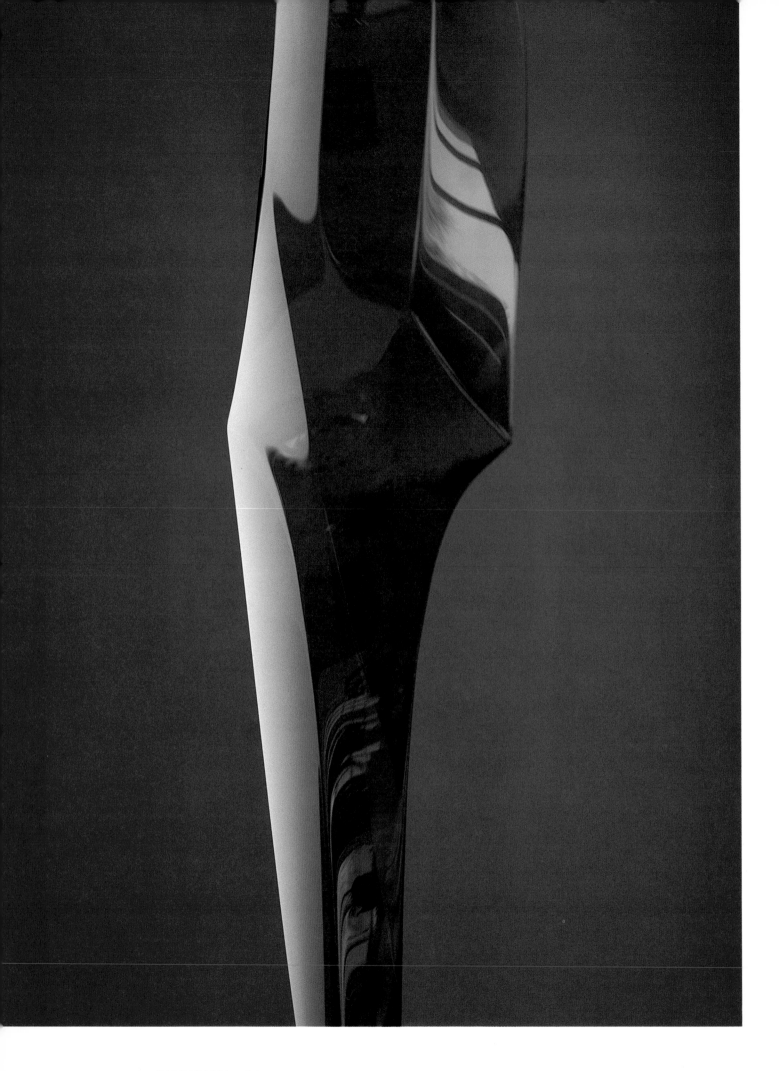

SAMURAI (details)

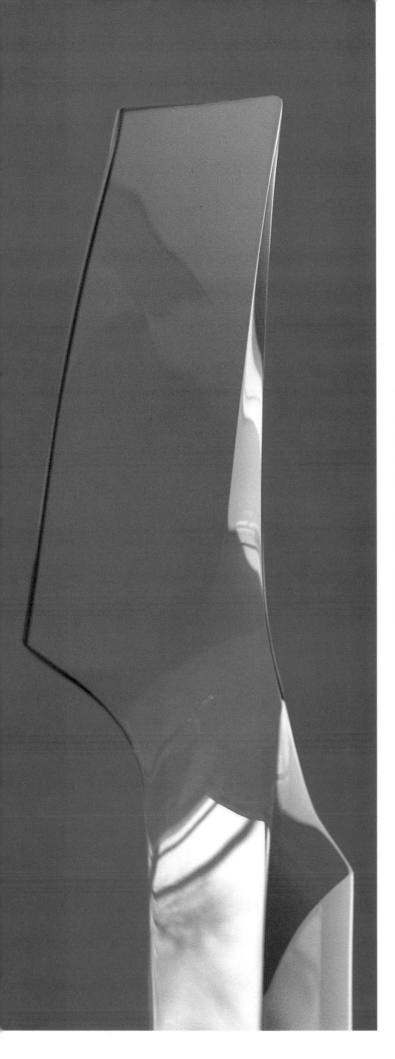
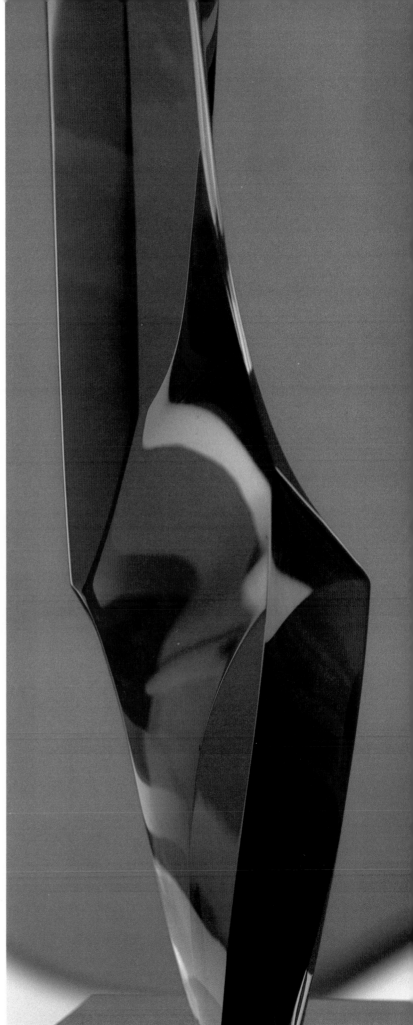

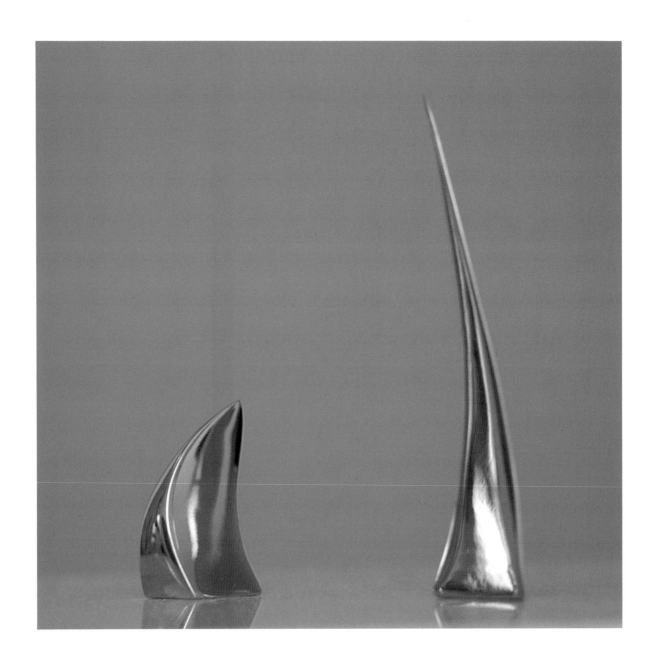

with representation (even some notable concentrations) in fields as surprisingly diverse as Antiquity, aerospace, Shakespeare, sports, French literature, engineering, and the fictional world of the Virginia novelist James Branch Cabell (1879–1958).

In part—as we might expect—this sheer semantic diversity reveals something of Safer's human character, as an omnivorous and brilliant reader, bilingually educated in English and French, whose mechanical bent and genius for high tech drew him first to the air force and then to communications. From that point, his talent for the world of affairs directed him to law school, real-estate development, and banking; he also has close ties to the world of sports. Above all, as is indicated by a title such as *Sophisticated Lady*, he has a sparkling and keenly developed sense of humor.

TANGO 1978 Polished steel on travertine base, 6×8×8 inches. Collection of Dr. Mortimer Feinberg, New York.

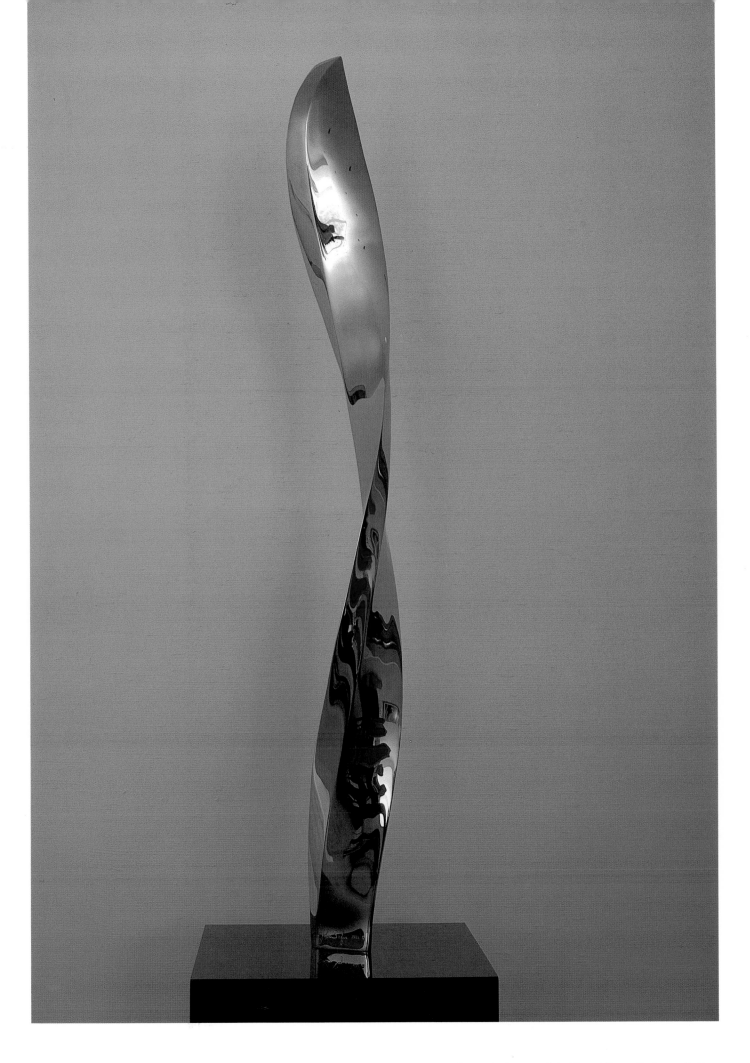

QUEST 1979 *Polished steel on black granite base, 50×8×8 inches.* Collection of the United States Embassy, Beijing.

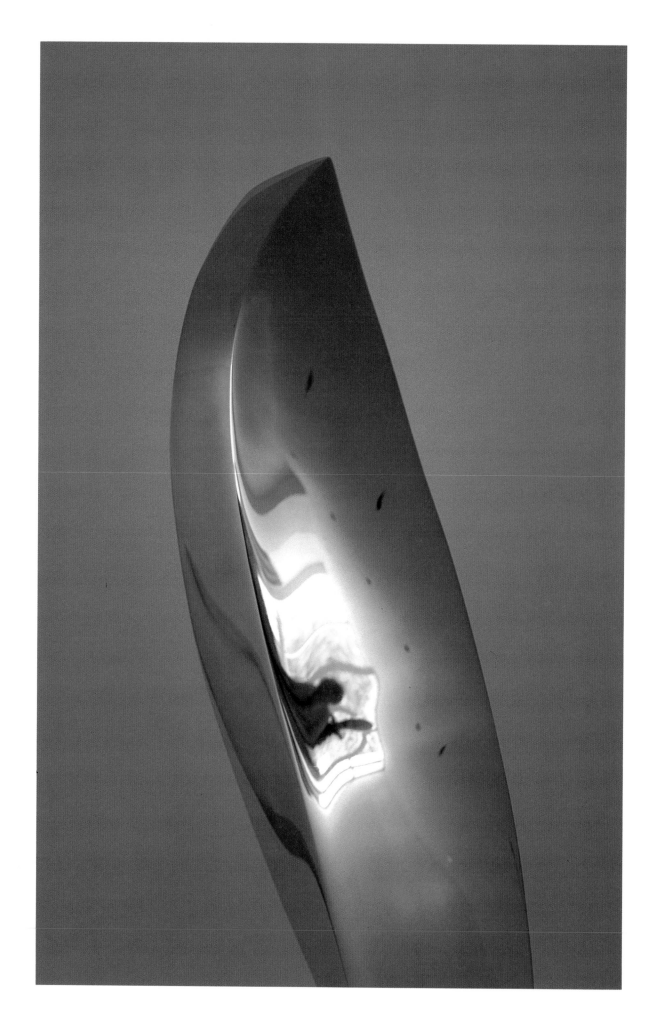

QUEST (details)

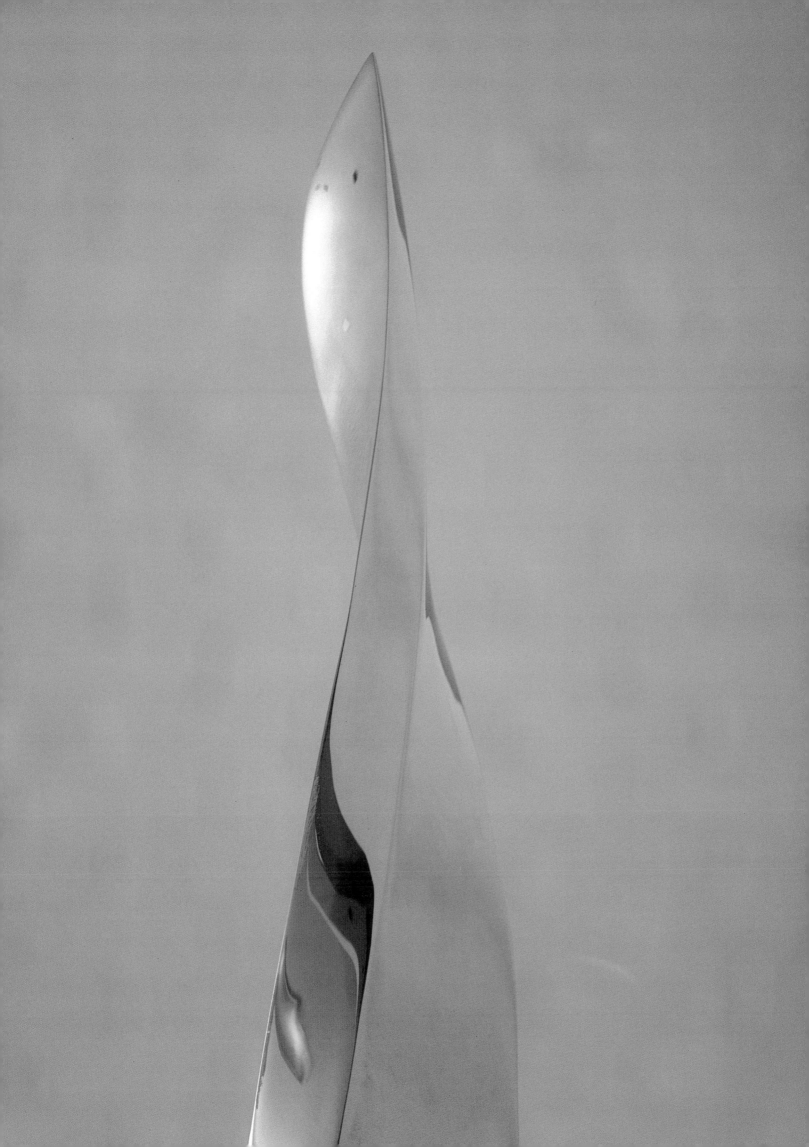

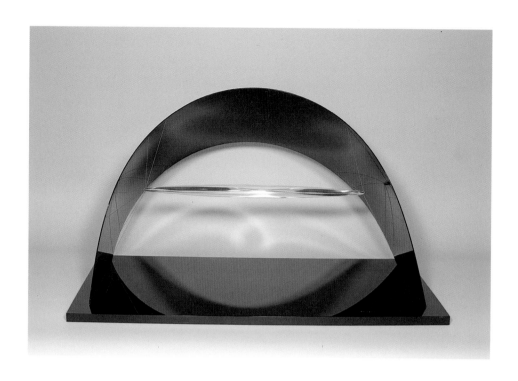

But his titles also document a close creative attention to the timeless community of artists, not only visual (*Laocoön Revisited, Bauhaus Remembered*) but literary (*Soliloquy*), and reflecting various religions (*Persephone, Shaman*) as well as several languages and cultures: *Cassandra*, from Pindar or Aeschylus; the *Anabasis*, from Xenophon; *Ariel*, from Shakespeare's *Tempest*; *Night Flight*, after Antoine de Saint-Exupéry's memoire; *Cockaigne*, from Mother Goose (though with a harsh homonymic pun); and a whole universe of mysterious and distant images from Cabell's writings: *Aigremont, Amneran, Anaitis, Bellegarde, Étarre, Flamberge, Poictesme*.

Safer, of course, has also labeled sculptures with straightforward, everyday words or terms in both his idiomatic languages—*Baby Grand, Window Box, Bird, Chandelle* (although this involves a double entendre with the term, used also in English, for an aviation maneuver), *Echo, Crystal, Cinquantaine, Mist, Smoke, Mistral*. But deeper or more ambiguous ideas show up both in French (*Déjà Vu*—with, of course, a bow to Freud) and in relatively standard English (*Interplay, Time Frame, Search, Symbol, Implication, Intrigue, Pathway, Unity, Judgment, Linkage*). Alongside the modernity of this language, however, runs a loftier, older-sounding idiom that is essentially classic: *Stasis, Plaint, Quest, Wraith*.

PERSEPHONE 1979 *Black and clear Lucite on black Lucite base, 22×30×15 inches.* *Collection of the artist, Washington, D.C.*

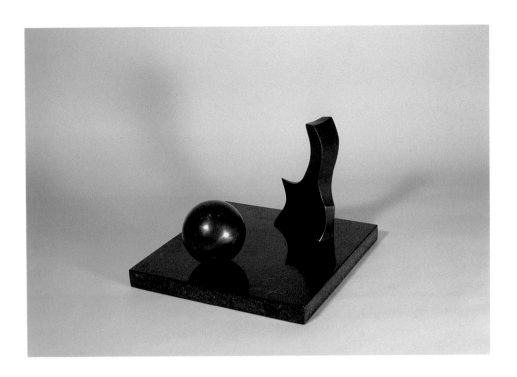

Only a few of Safer's titles, mostly early ones, are direct descriptions of appearance or function—*Multicube, Twist, Cube on Cube, Timepiece.* A few others are simple, familiar terms from athletic or recreational activities: *Spring Dance, Tango, Swing, Serve, Before the Wind.* Even here, however, a typical pun—both verbal and visual—makes *Swing* equally eligible as an image of dance or golf; another such, more characteristically mysterious, is *Clovis*—referring to the first Merovingian king of the French, but also to the earliest classic phase of North American archaeology. Some other works draw their names from older traditions of sculpture, or, more precisely, from archaeology— *Monolith, Stele, Terminus* —though other, often punning references hint at cultures just as remote: *Logos, Pisces, Ourabouros, Samurai, Golden Horn.* Just one sculpture is named for a living person, Safer's daughter *Janine.*

The great majority of Safer's verbal as well as visual imagery reflects his interests in engineering, aerospace, and astronomy. Some titles, again, are familiar terms or concepts: *Torque, Ascent, Line of Flight.* Some are unabashedly speculative, relating to astrophysics or philosophy: *Web of Space, Limits of Infinity, Null Space.* A few that at first glance seem straightforward become a bit unsettling on further consideration—*Leading Edge, Knife Form, Probe,*

LINKAGE 1981　*Patinated bronze on black granite base, 9×12×12 inches.*　*Collection of the artist, Washington, D.C.*

Space Thing. Other titles frankly reflect contemporary tensions: *Confrontation, Challenge, Siege, Flare, Trajectory, Flame, Conquest.* Several more resolve such tensions and form a quiet coda to the encyclopedic virtuosity of this exceptional artist: *Laocoön Revisited, Balance of Power, Bird of Peace.*

The range of his subjects conclusively demonstrates that Safer is an artist— a critical contemporary—who thinks as well as creates. We are all the beneficiaries of his reflective, visionary genius.

Douglas Lewis
Curator of Sculpture and Decorative Arts
National Gallery of Art, Washington

John Safer: The Sculptor in Context

by Walter J. Boyne

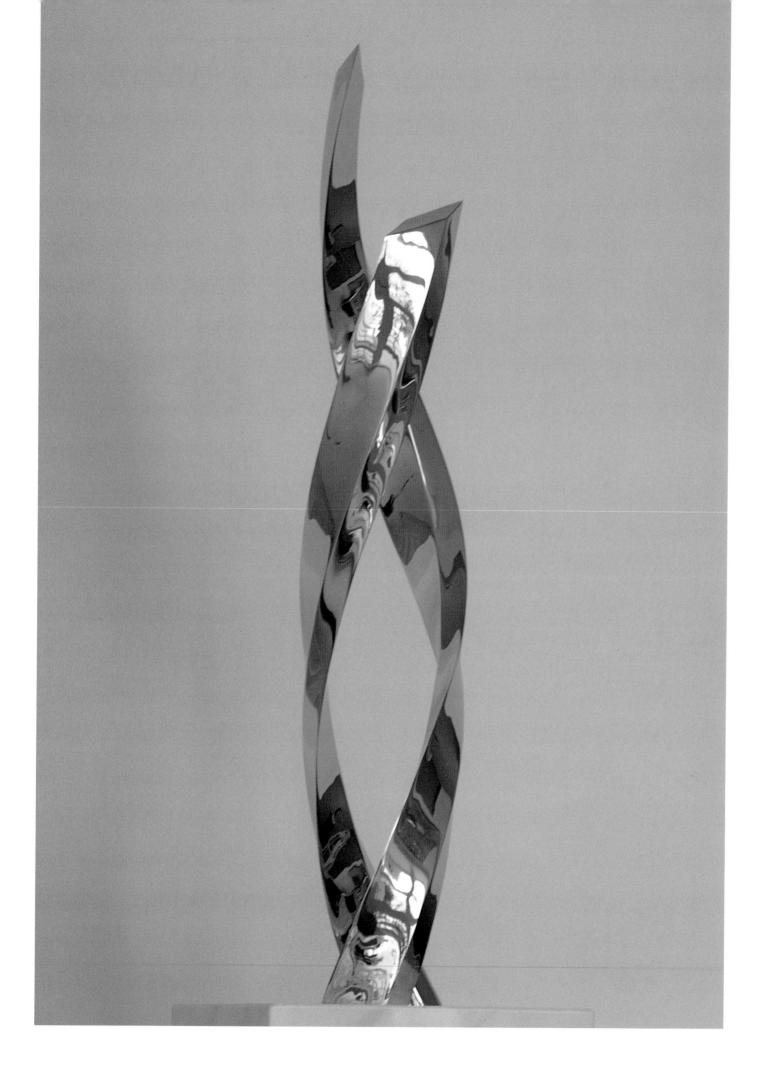

I An Analogy

INTERPLAY III (with detail) 1979 *Polished steel on white marble base, 54×18×18 inches. Collection of Ambassador and Mrs. William B. Schwartz, Jr., Longboat Key, Florida.*

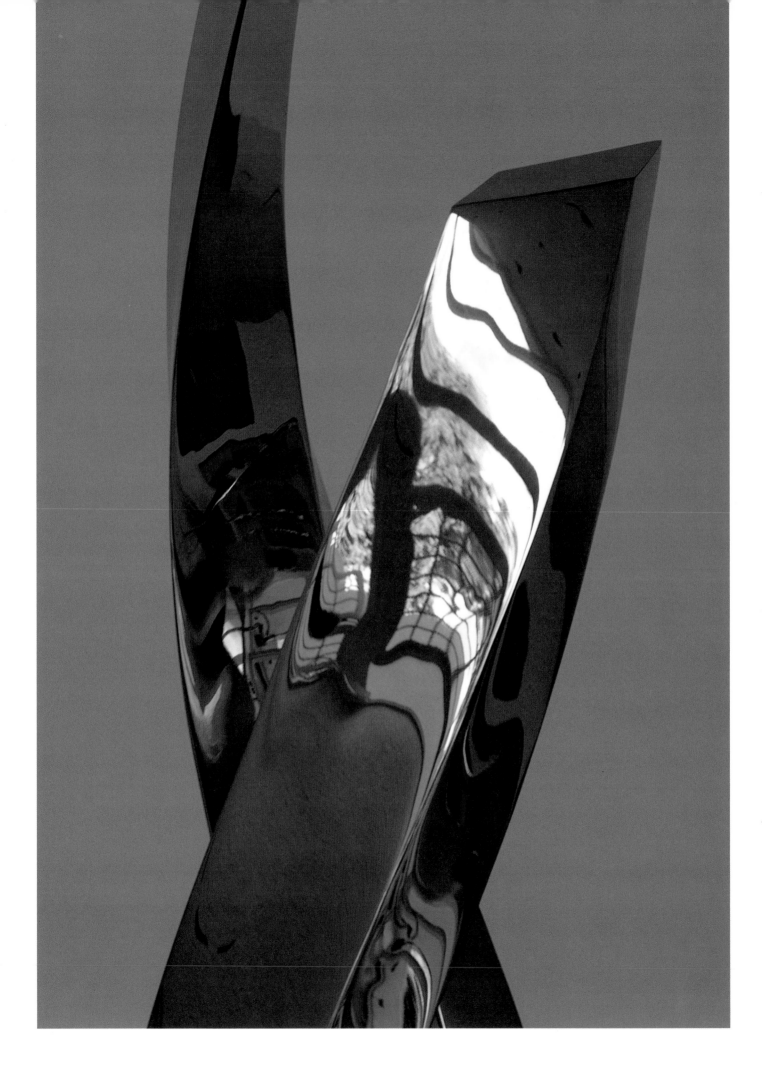

INTERPLAY III (detail)

There is a fundamental, if often overlooked, relationship between mathematics and art. John Safer and I have often discussed this relationship, postulating that somewhere there exists an algorithm that reduces the curves and mass of an aircraft to music. There should be a similar algorithm that extrapolates musical works into three-dimensional physical forms. A strong exemplar of this relationship can be found in the sculpture of John Safer.

Yet although John has a talent for mathematics, he has not used formulas in creating the broad spectrum of his work. Instead, his work springs from an unusual, almost contradictory combination of intuition and methodical development. His intuitive nature is extraordinarily sensitive to both intellectual and emotional stimuli, and an initial vision of the ultimate work often springs immediately to his mind. But the fulfillment of that vision in a finished sculpture is the result of systematic development, in which he uses an iterative approach to bend his technique and materials to fit his vision.

John has used this dialectical process of vision and perseverance from the very start; initially, vision dominated, for his earlier works were less technically demanding. Later, as he began to expand his knowledge of techniques and materials, the increase in the scope of his vision was matched by ever finer, more laborious craftsmanship.

When asked to write this book on John's work, I was initially nonplussed. I knew that I liked his sculptures, but being neither an artist nor a critic, I was not certain at first that I could deal with them intelligently. My experience drives me to historical analogies, and

4 3

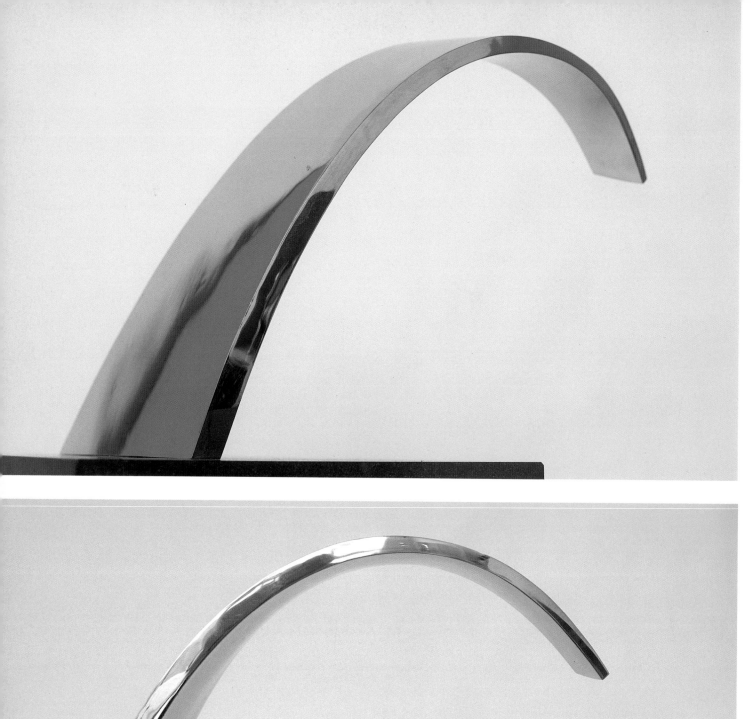

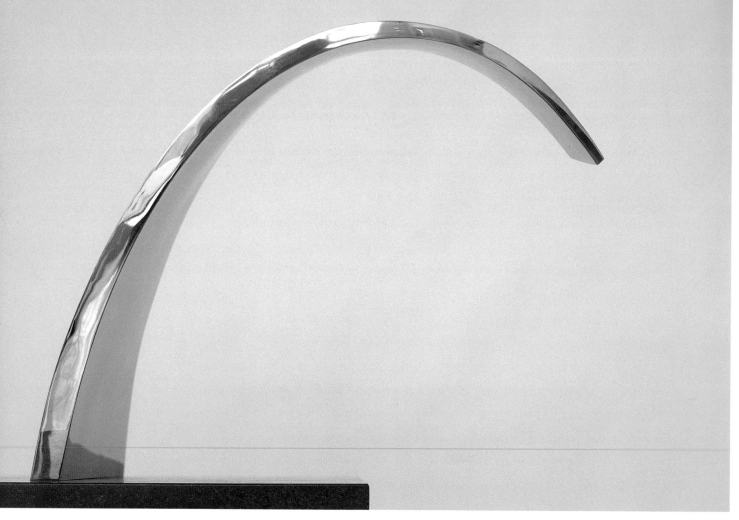

TRAJECTORY (with detail) 1981 *Polished bronze on black Lucite base, 16×20×20 inches. Collection of Mr. and Mrs. Jonathan B. Whitney, New York.*

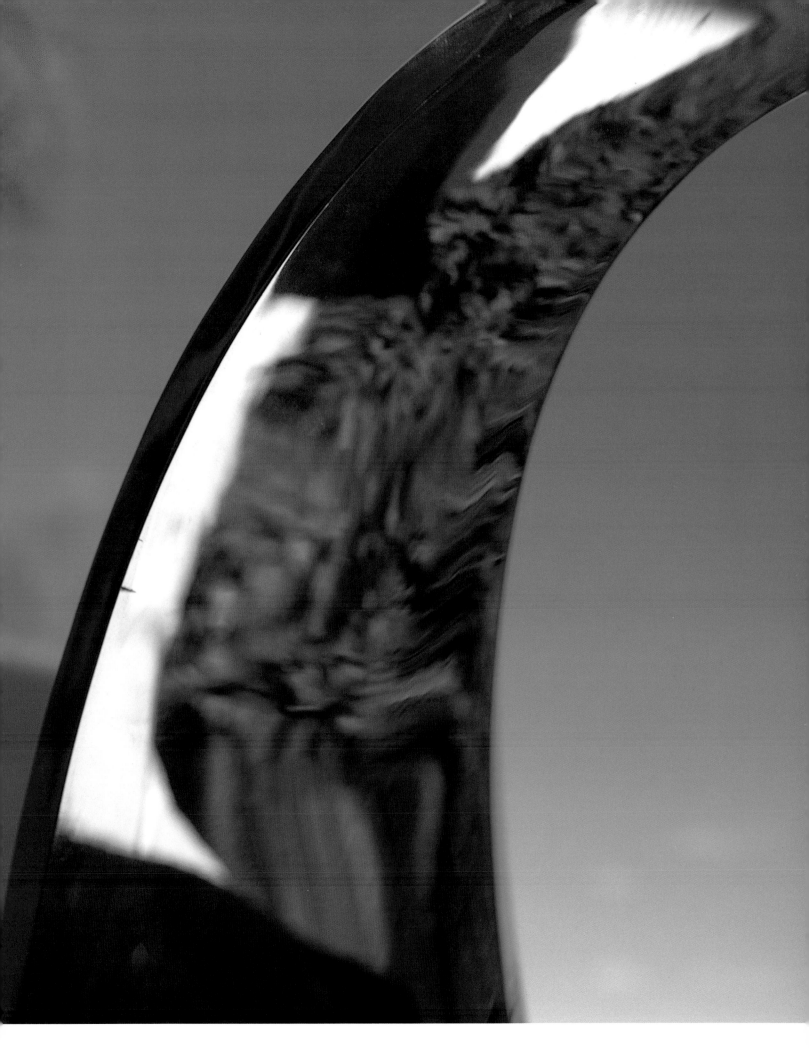

in pondering the relationships of art, mathematics, and flight in John's works, the writing and philosophy of Antoine de Saint-Exupéry come to mind. The Frenchman Saint-Exupéry, who died in combat during World War II, was a flyer, writer, and philosopher, while John Safer is a banker, businessman, sportsman, and sculptor. The two men naturally have many differences, but they also have many thought-provoking similarities.

Physically, they are almost polar opposites. Saint-Exupéry was a great clumsy bear of a man who instantly became the center of attention in any room he entered. In sharp contrast, John is a man of medium height and build who moves quietly and easily.

The two men differ again in taste and manners. Saint-Exupéry ate with gusto and was a prodigious drinker as well, and quite happily imposed his life-style on all those around him. John is by nature abstemious and drinks no alcohol at all. It would be unthinkable for him casually to intrude on another's life-style.

While the differences are pronounced, the similarities are more interesting. The gregarious Saint-Exupéry's anecdotes transcended mere storytelling; they were virtual one-man plays. A lifelong fan of Saint-Exupéry, John too is a master raconteur, with a remarkable ability to produce from his inexhaustible memory a story, quotation, or incident appropriate to a situation. Saint-Exupéry was an almost supernatural master of card tricks; John, too, is adept at sleight of hand.

To carry the comparison further: it is not generally known that Saint-Exupéry was a sometime scientist and inventor. John's talents are equally multifaceted. After serving in the United States Air Force during World War II, he graduated from Harvard Law School and then, for a time, was the program director of a television station. He is at least part scientist and has designed and built his own stereos and television sets, as well as other more complex and exotic electronic devices. He is an amateur astronomer with a deep interest in theoretical physics and cosmology and is, of course, a master craftsman, as evidenced so well by his sculptures, which he often shapes, machines, and polishes himself.

But the most pertinent similarity between Antoine de Saint-Exupéry and John Safer is that each man conquered two utterly dissimilar fields, one pragmatic, the other an art form.

In the 1930s and 1940s, Saint-Exupéry became one of the most famous flyers in the world, braving gales over the Andes, flying—and crashing—in the Sahara, fighting in the losing air war over France. At the same time, he established an international reputation as a novelist and poet.

Similarly, John Safer has carved out two highly successful careers. In the wolf's den of the Washington, D.C., business world, he has achieved much, first in real-estate devel-

TRAJECTORY (detail)

opment and then in finance. He is currently a leader of the Washington banking community. At the same time he has attained a worldwide reputation as a sculptor.

Just as Saint-Exupéry's writing is related to his aviation experiences, so is John Safer's sculpture related to his love of aviation and space technology. Yet it is their fundamental philosophies, and the effect of these philosophies on their work, that warrant the closest examination.

It was Saint-Exupéry's essential belief that each individual must meet his responsibilities; that there can be no growth except in the fulfillment of obligations; and that only in that fulfillment can one find the solidarity that binds human beings together—the pilot to his unit, the artist to his work. He sought that solidarity in flight and found death; he sought the same solidarity in literature and found immortality.

As Saint-Exupéry validated his philosophy in his writing, so does Safer in his sculpture. The eminent critic Frank Getlein, in his fine 1982 book *John Safer*, phrased an eloquent counterpoint to Saint-Exupéry's thinking, saying that Safer "created sculptures which give a new vision of ourselves and of our universe."

II Trophies

SWING 1977 *Polished brass, 48×36×36 inches.* *Collection of Commissioner Deane Beman, Firestone Country Club,*
Akron, Ohio.

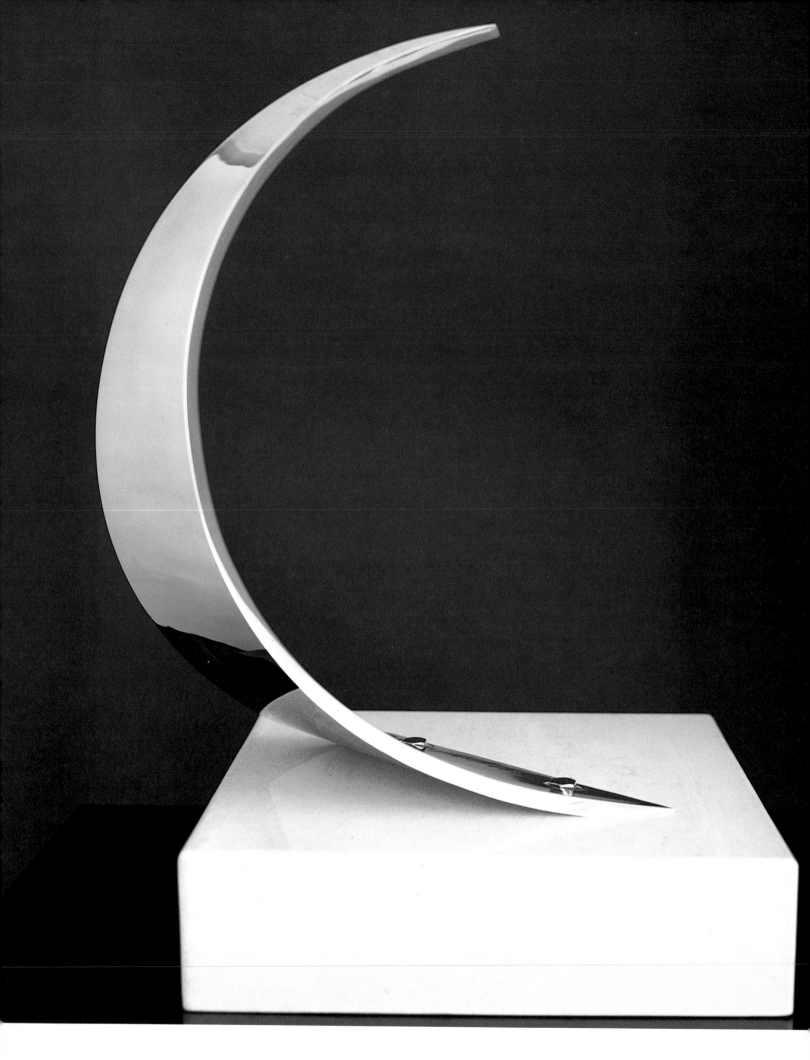

BEFORE THE WIND 1987 *Polished steel on travertine base, 27×20×16 inches.* Collection of Mr. and Mrs.
Richard Dubin, Bethesda, Maryland.

On September 12, 1985, a show of John Safer's work opened in the main lobby of the National Air and Space Museum in Washington, D.C. I was director of the museum at that time, and had come to the conclusion that an exhibition of John's sculpture would be appropriate in that setting, at the center of the most visited museum in the world. Not surprisingly, I met considerable resistance from my staff when I proposed placing a show of contemporary art in the center of the museum. As it happens, the museum has an art gallery on the second floor, at the end of the building and away from the areas that receive the great bulk of visitors.

Most of the staff felt that this art gallery was the proper place for a show of modern sculpture, while some of the die-hards pointed out that the Hirshhorn Museum was only about two hundred yards away, and that it might be an even better venue.

I felt differently, for personal reasons. When I was about eight years old, I had stumbled across a picture of Brancusi's famous *Bird in Space* in an encyclopedia, and was immediately struck by the fact that the piece, so wonderfully beautiful, closely resembled a wing or a propeller, and thus linked aviation and art. As my fondness and appreciation for aircraft grew over the years, I continued to see *Bird in Space* as a metaphor for the beauty of flight.

Then, in 1975, I had the privilege of supervising the reassembly and suspension of the Hughes racing aircraft in the museum. Howard Hughes, now remembered primarily for his wealth and eccentricities, was in 1934 a dynamic young man in the forefront of aviation.

He was also an excellent pilot who instinctively picked the best people to work for him. Hughes wanted to build the fastest plane in the world, one that could set a new speed record—and then perhaps be sold to the Air Corps as a fighter. He provided a general sketch of the aircraft he wanted, and in typical Hughes fashion relieved his design team of all financial constraints. Together they developed one of the most beautiful aircraft of all time, a sleek monoplane in which he indeed set a new world speed record in 1935.

As the racer (stored for nearly forty years, but in excellent condition) came together, I was once again struck by the absolute relationship between aerial forms and art. The lines of the Hughes racer, from its bell-shaped cowling through its sleek wing fillets to its finely tapered tail, are magnificent. If it had never flown at all, it would have been worth building simply as a sculpture, and I mentally paired it with the Brancusi; only later did I pair it with the subject of this book.

In 1983 I first became acquainted with John Safer and his work and realized that he had gone farther than Brancusi in integrating the relationship between aeronautics and art. His works are as dynamic at rest as the Hughes racer had been in flight—and I knew that the place for them was in the entrance lobby of the museum.

Fortunately, the 1985 show proved to be an outstanding success in every respect, receiving both excellent critical reviews and wide approval from the public. The success was due in part to the beautiful way in which the pieces were exhibited. Individually they are remarkable; collectively they are fantastic. A great part of the impact stemmed from the inherent qualities of John's sculpture. Yet there was another element: the fact that these same qualities so perfectly complemented, and were so perfectly complemented by, the artifacts of air and space within the building.

The relationships among art objects and aerospace machines are both broad and deep, extending not only to shapes and materials, but to the very dynamics of flight. There is an aphorism in aviation: "If it looks right, it will fly right"; most of the air-and-space objects in the museum can be judged by this rule. John's works "looked right" for exhibition in an air-and-space museum, and they flew, metaphorically, in terms of visitor appreciation.

There was one noticeable and unpredicted side effect of this exhibition. Ordinarily, the stream of visitors to the museum hurries through the entrance area and bustles directly to either the Milestones of Flight Gallery, where the Wright Flyer hangs, or the Langley Theater to see one of the great IMAX films.

With the Safer sculptures on exhibit, this pattern changed. The public tended to stay in the lobby for longer periods, in order to enjoy the sculpture. An internal traffic problem was created as queues of people lined up to admire individual works within the exhibition,

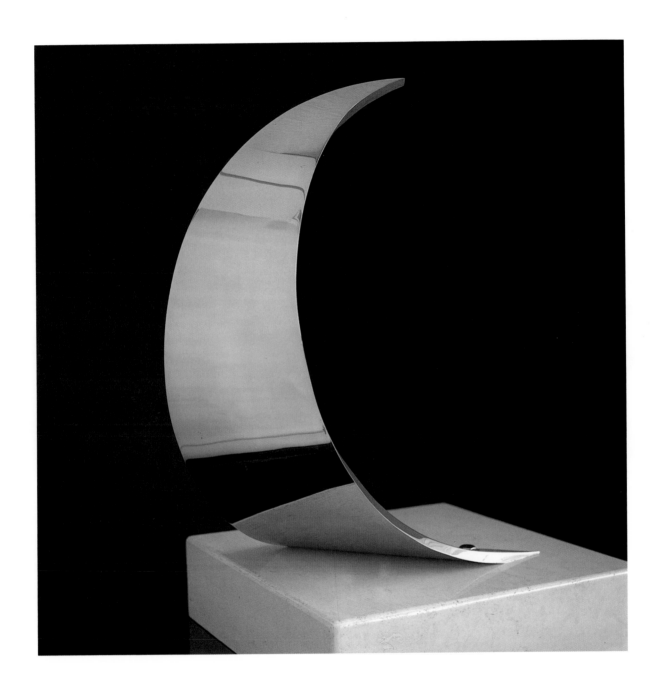

BEFORE THE WIND

a phenomenon that had never occurred in the art gallery proper. Patrons wrote to me to say that they had come to the museum to see our exhibits, but had used up their allotted time looking at the Safer sculptures.

This was gratifying, but not surprising. John's sculpture offers a challenge to the eye and mind, the shapes stimulating imagination much as do cloud formations on a summer day. But unlike ephemeral clouds, and very much like the air- and spacecraft within the museum, his work combines a spiritual lift with fascinating forms that have permanence and worth.

The exhibition in the museum had its genesis in one of John's very best works, *Web of Space* (1985), which became the National Air and Space Museum Trophy. Two separate sets of events led to the creation of this lovely piece that so aptly symbolizes both the vastness and the unity of the universe.

The first of these occurred in 1982. A group of Americans had been formed to organize events to commemorate the bicentennial of the end of the American Revolution. A member of this group was Abigail McCarthy, the wife of Senator Eugene McCarthy and owner of a Safer sculpture. The group was seeking a sculpture to be placed in Grosvenor Square in London, facing the American embassy, in honor of the bicentennial. Mrs. McCarthy recommended John, and an art committee was dispatched to study Safer's work and discuss a possible commission.

One of the members of the committee was a woman of remarkable ability and vision, Janet Solinger, who has brought the Smithsonian Institution's associate programs to their present stature. She took John aside to tell him that she did not believe it likely that an American sculpture would ever stand in Grosvenor Square, an opinion that subsequently proved to be accurate. However, Janet went on to tell John that she was impressed by his work and suggested that it might be worthwhile to discuss placing something in the Smithsonian, particularly at the Air and Space Museum.

Coincidentally, I had been thinking about creating a National Air and Space Museum (NASM) Trophy for some time. There were already a number of prestigious national air-and-space awards—the Langley Medal, the Wright Trophy, and the Collier Trophy, to name only three—but I knew that there was room for another, rather more special trophy, one with a dual purpose.

One purpose, of course, would be to honor—with no commercial overtones— current leaders in the world of air and space—pilots, engineers, designers, manufacturers— whoever might have accomplished in recent times a feat worthy of a major award. In addition, there would be a second award, a retrospective trophy, one that would honor people who had perhaps been overlooked in their own time, but who were subsequently recognized as having been great contributors to the field.

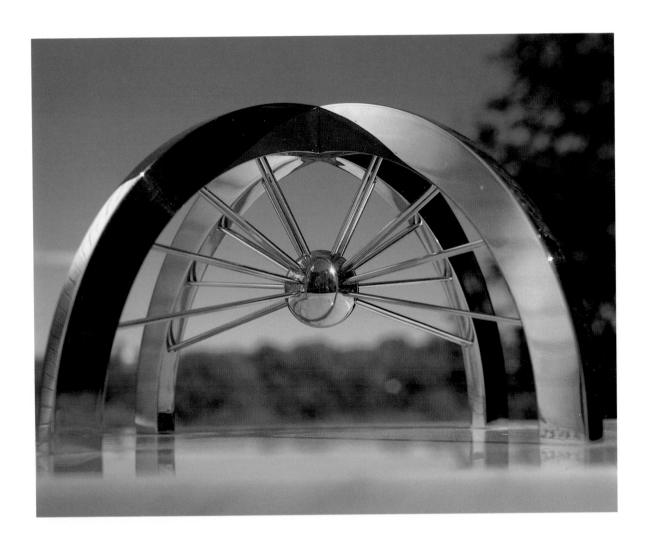

The advantage of this approach was that it could honor people from a vastly broader spectrum than did the other trophies. It is a sad reality that for political and business reasons, contemporary honors in research and industry are often awarded not to the real pioneers who do the work, but to powerful executives or company owners. The NASM Trophy approach also allowed for a universal overview, one that could transcend geographical boundaries by permitting consideration of foreign nationals for the award, including those who might have made their great contributions to air and space at a time when their native land was at war with America.

With these concerns in mind, I met John at a lunch arranged by Solinger. We found that we had the same inherent love for the beauty of flight, and we quickly agreed that he would not only attempt to create a NASM Trophy, but would also develop the work so that a

WEB OF SPACE 1985 *Polished steel on black granite base, 24×48×48 inches.* *Collection of National Air and Space Museum, Washington, D.C.*

smaller-scale version of it could be presented each year as an award. The large version would remain at the museum.

He more than achieved his goals with the timeless design for *Web of Space*. The large version stands twenty-four inches high, while the small edition is eight inches high. John later told me that, as so often happens with him, the design for the work had come to him in an instant, and he had conceived of the essential sculpture, as well as its title, while I was explaining to him my general hopes for the project.

Since then, the National Air and Space Museum has awarded its trophy to such luminaries as Edwin Land, the great inventor and industrialist, for his contributions to aerial photography, Hans von Ohain and Sir Frank Whittle, inventors of the jet engine, and Dick Rutan and Jeanna Yeager, for flying around the world nonstop, without refueling. An additional sculpture was presented by John to President Gerald Ford for his interest in, and support, of the air-and-space program.

John and his wife, Joy, presented me with a version of the work; it sits on my desk now, and I am constantly amazed at how correct his concept was, and how appropriate the title. Mounted on a black stone base, two shining steel arches intersect at ninety degrees. Beneath them is a sphere, connected to the arches by steel rays. It is a true image of space's great web, interrelated, interdependent, yet reaching toward inifinity.

It was apparent to me from the first that while the NASM trophy measures less than three feet across, the concept would lend itself handsomely to enlargement on a grand scale. In some of the preliminary drawings for the proposed extension of the National Air and Space Museum to acreage near Dulles International Airport, I had the architects sketch in a mammoth version of *Web of Space*, with arches one hundred feet in diameter. The enlarged *Web of Space* looked absolutely perfect in the sketches—so perfect in fact that it was puzzling. Then the reason for this remarkable interrelationship came to me. *Web of Space* had an inherent harmony with Eero Saarinen's beautiful terminal building at Dulles Airport, and was an ideal artistic bridge from that soaring structure to the necessarily more functional museum buildings.

Web of Space was not John's only trophy design, just as aviation and space are not his only love, in spite of the tremendous influence these disciplines have had upon his art. Sports have always played an important part in John's life. He is a skilled golfer and a tough competitor in everything from sandlot football to volleyball, gifted with remarkable eye-hand coordination; he was once a two handicap at golf, and still plays to a six. Starting in his teens, in addition to following the great American tradition by playing football and baseball, he won tournaments in bowling, horseshoes, and table tennis. He has a closet full of golf trophies and is still an enthusiastic competitor in tennis. But John does more than play tennis, he fosters its

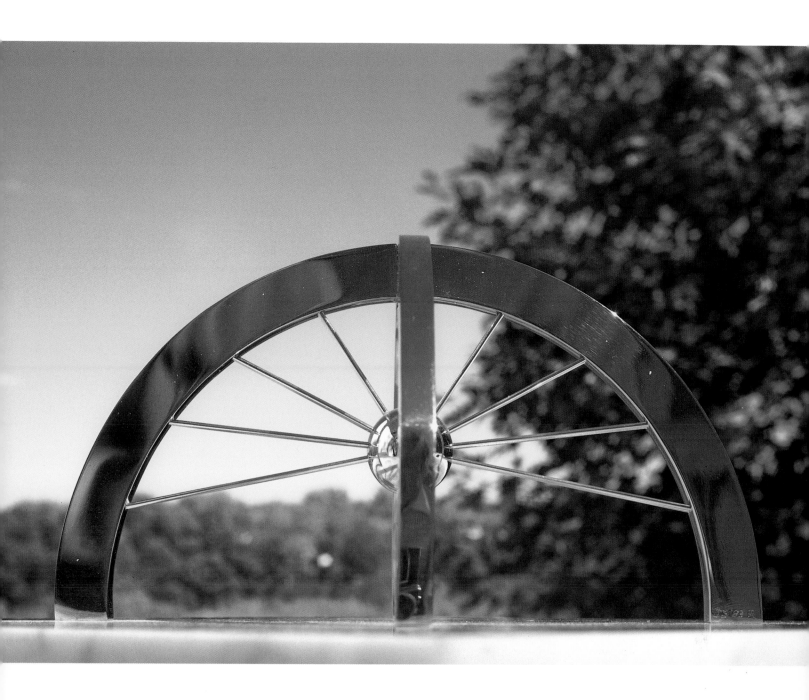

growth by helping to sponsor tournaments and by seeing that underprivileged children are provided an opportunity to receive training in the sport.

So it was quite natural that earlier in his career he had been called upon to create sculptures relating to golf and tennis. His Sovran Bank Classic trophy, *Serve*, 1989, was created in bronze and granite, and is a little over six feet tall. Later, a monumental version rising twenty feet in the air was installed in front of the FitzGerald Tennis Center in

WEB OF SPACE

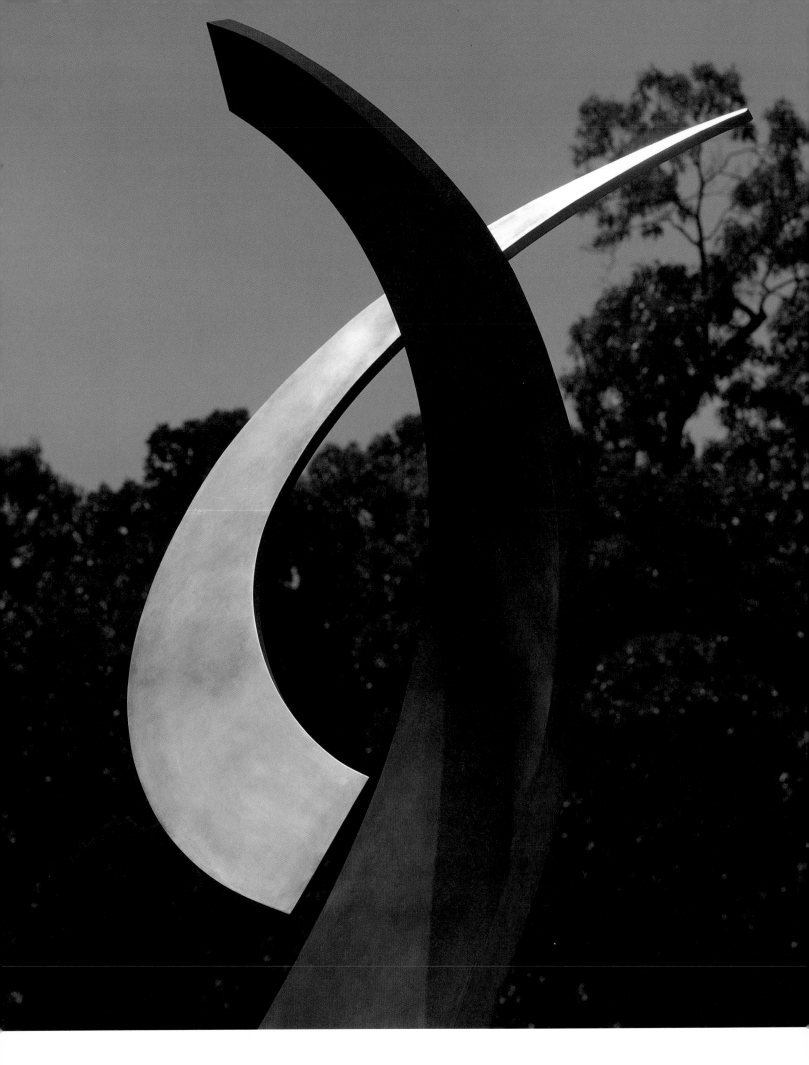

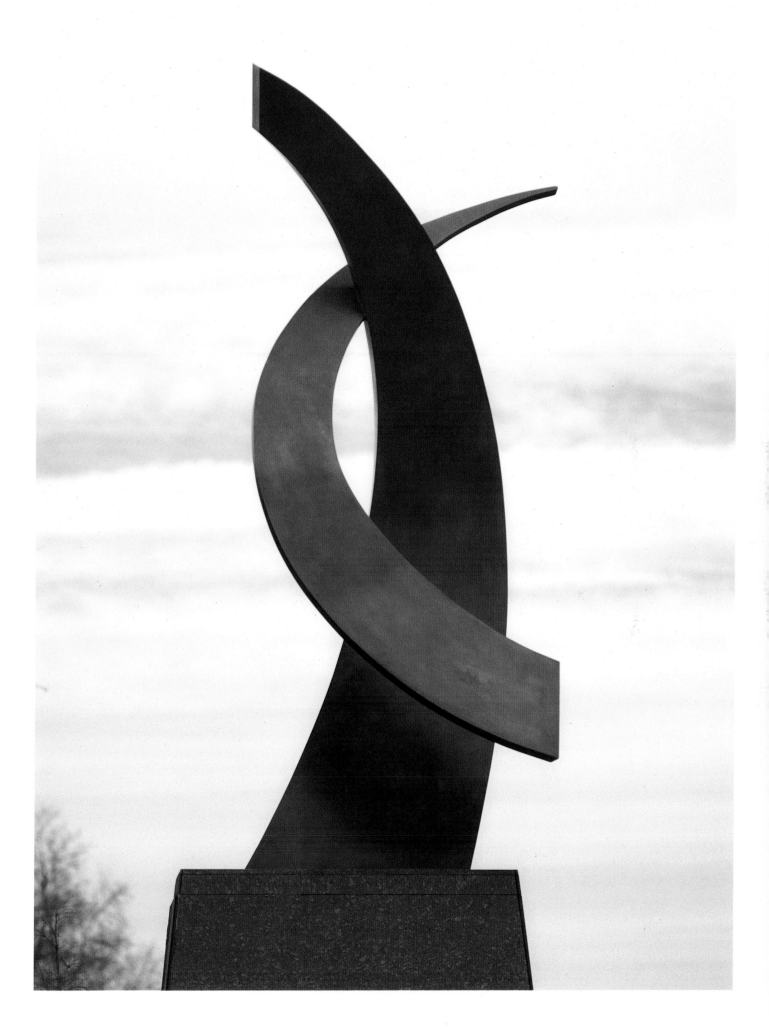

SERVE (with detail) 1989 *Patinated bronze on blue-black granite base, 20×6×6 feet. Collection of the Washington Tennis Foundation, Washington, D.C.*

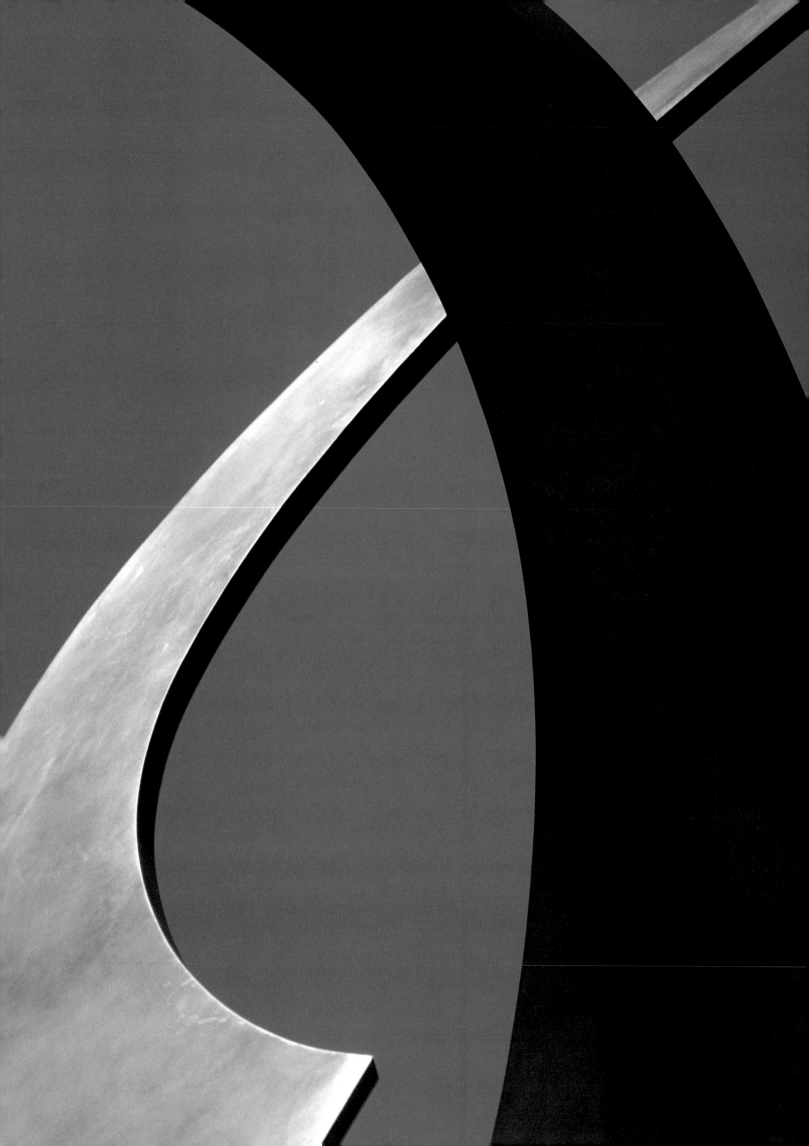

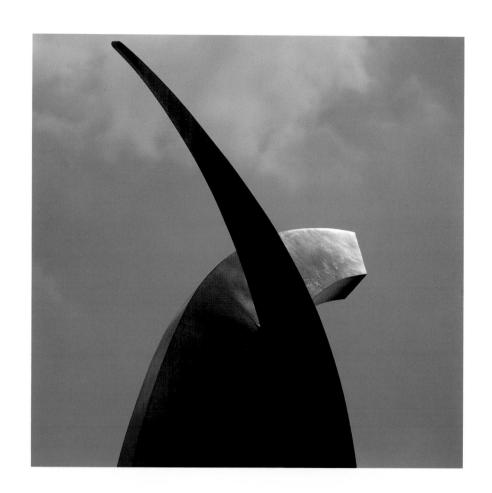

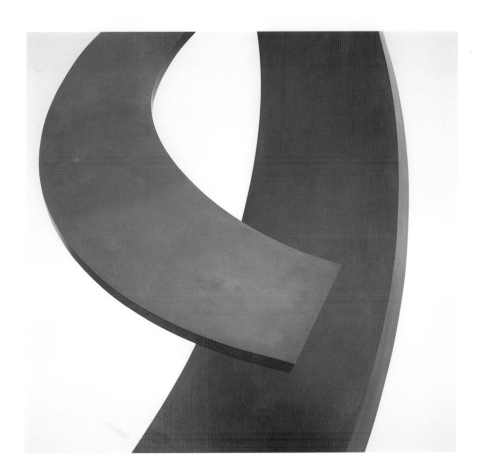

SERVE (details)

Washington. The vertical element, the stylized athlete, is a dynamic arc of contained energy; you can sense the power of the muscles drawn up to strike and almost hear the grunt of release as the horizontal element, the stroke, is delivered. The stroke is another arc, tangent to the upright, and conveys the flow and harmony of tennis.

Safer created *Swing* (1977) for the Professional Golf Association tournament, the World Series of Golf, which is played annually at the Firestone Country Club in Akron, Ohio. Sculpture and base stand seven feet high. The work is made of polished bronze and is a pure, stylized expression of a perfect golf swing. The eye follows the sculpture's travel as it swings in a dynamic arc, narrowing, where it spends its energy upon the ball, from a broad, almost massive sheet of power, via a tapered, decreasing radius, into the perfect follow-through.

From my specialized viewpoint, I see the trophies as expressive of two modes of power. *Serve* seems to me, in air-and-space terms, to convey the same sort of contained kinetic energy that a high-performance sailplane generates when it has caught the thermal of a lifetime. All the tension and the about-to-be-released energy of soaring are felt through the length and breadth of the trophy. In a similar way, *Swing* has the unleashed power of a turbine engine; it seems to spin on the stand, endlessly delivering the flow of forces contained within it.

John has created another sculpture, one of high purpose, intended also to serve as a trophy—his *Bird of Peace* (1989), a work that, like many of his sculptures, has a complex genesis.

In the late 1970s, John gave a painting done by his friend James Twitty to the Aspen Institute in Colorado. As a result, he met the institute's vice-president, Dr. Stephen Strickland. More than a decade later, in 1985, Strickland called John to say that he was now the president of the National Peace Institute Foundation, and wanted to commission a sculpture that would symbolize world peace. Partly due to the work of this foundation the U.S. Congress had, in 1984, taken an unprecedented step, creating the United States Institute of Peace, a state-sponsored and -funded body whose mission it was to work for world peace, in this case through research, analysis, and education.

The sculpture, like *Web of Space,* was also intended to function as the model for a trophy, to be awarded biennially: a small version of it is given to the person or persons deemed to have accomplished the most for world peace during the previous two years.

Once again, John was able to create the design of the sculpture almost instantaneously, before Strickland had finished his phone call.

John's analysis of his capacity for instantaneous creation is that it is akin to intuition. He believes that when one has an intuition or a hunch, the only instantaneous aspect of the matter is awareness. It is his theory that the mind has been working on the problem, or in any case on related problems, for some time, bringing together disparate data

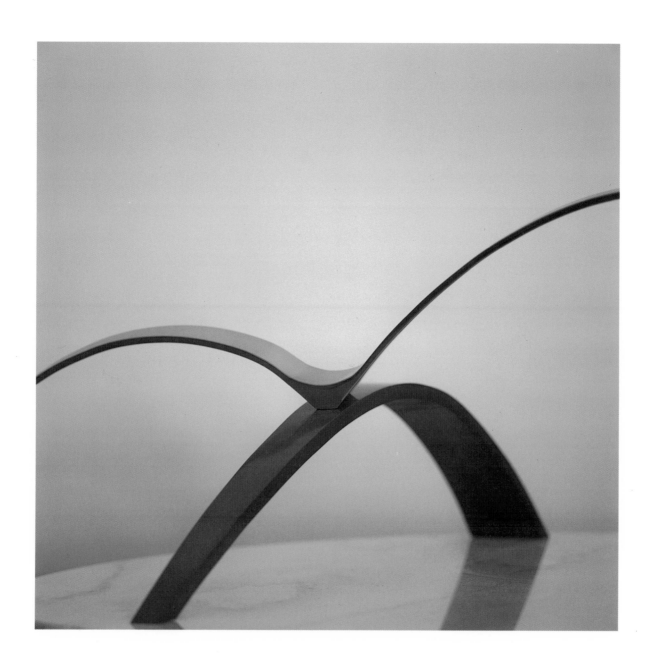

and ideas, and that the intuition is merely the moment in which everything merges into a conclusion.

When Strickland uttered the word "peace," John automatically thought first of the dove that has been used for millennia as the emblem of peace. Yet because his concept of flight is always dynamic, his mind quickly transcended the image of the traditional dove alighting on the ark with an olive branch in its mouth, and moved to one of nature's most

BIRD OF PEACE 1989 Polished and patinated bronze on white marble base, 15×30×30 inches.

Collection of the National Peace Institute Foundation, Washington, D.C.

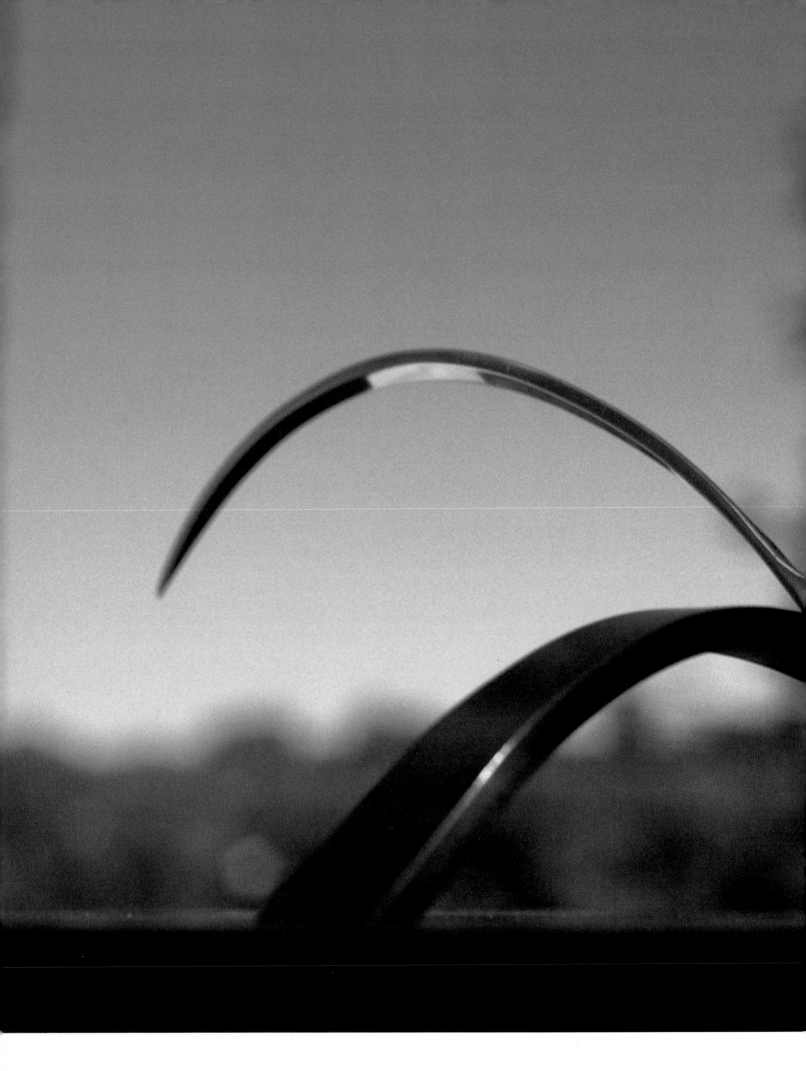

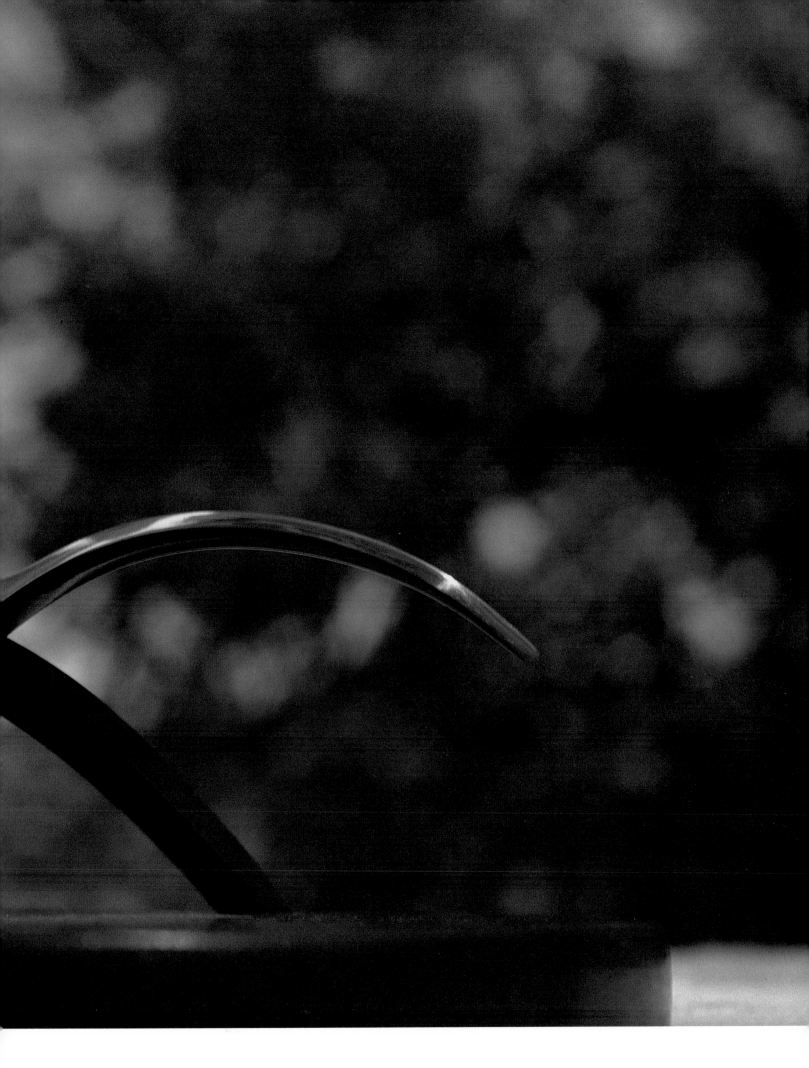

BIRD OF PEACE (maquette) 1989 Polished and patinated bronze on black granite base, 12×12×12 inches.

Collection of Secretary General Javier Pérez de Cuéllar, New York.

beautiful and graceful flyers, the gull. Another factor entered his mind at this point. With the Cold War just ending, the chances for world peace were looking better than they had for decades. Why not, therefore, put the bird on the wing?

Before the phone conversation had ended, John had visualized a complete design, an abstraction of a bird, derived from his memories of gulls in flight, soaring over a globe represented by an arc. The final touch came as he realized that the ultimate beauty of a flying object lies in its perception by the mind, so that *Bird of Peace* should be seen as the human eye sees a bird in flight. John turned his flyer in midair, foreshortening one wing, and the sculpture was complete.

The original sculpture stands today in Washington, D.C., at the headquarters of the National Peace Institute Foundation. A second cast is in the lobby of the United States Embassy in London, given by the artist in honor of his longtime friends, Ambassador Henry Catto and his wife, Jessica.

The first trophy was awarded to Secretary General Javier Pérez de Cuéllar of the United Nations, and stands today in the U.N. Conference Room. Additional trophies were given to Senator Mark Hatfield and to Father Theodore Hesburgh, the former president of the University of Notre Dame.

III Facets and Flames

LIGHT BOX 1970 *Black and clear Lucite, 14×14×20 inches. Collection of Mr. Robert van Roijen,*

Palm Beach, Florida.

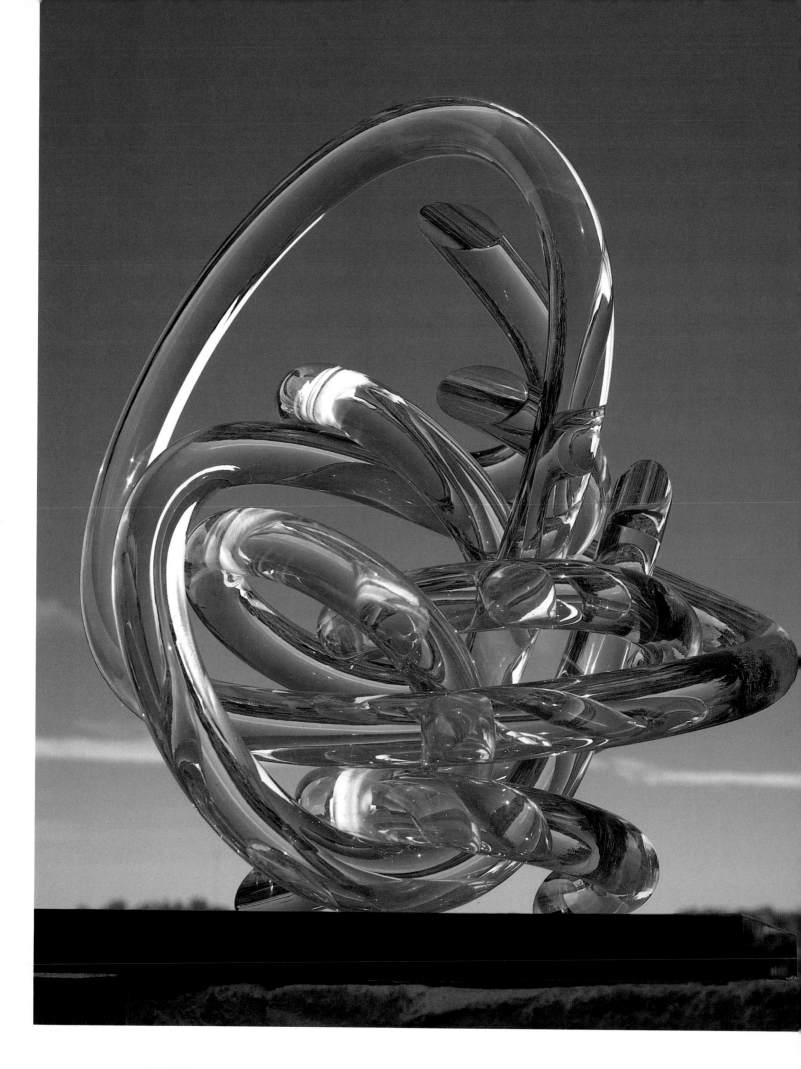

TWIST 31 1969 Clear Lucite on polished brass base, 19×18×12 inches. Collection of the artist, Washington, D.C.

When John began to work as a sculptor in the late 1950s, he was drawn to Lucite, a material rarely used for sculpture, and only in a limited way. It was, however, one for which he had long had an affinity.

His love affair with Lucite had actually begun in the first grade, when a teacher brought to class a picture of a work by Irene Rice Pereira, an artist who created Constructivist pieces using Lucite. Even when Safer was a small child, the transparency and reflective qualities of the material had spoken to him, stirring him in a way he was not then able to articulate. Much later, his own first sculptural experimentation with Lucite was Constructivist, as he joined segments of basic geometric shapes—rods, discs, cubes, and pyramids—to form a total design.

Lucite has had an enduring relationship with the air-and-space industry. It is the best-known name in the United States for polymethyl methacrylate, a plastic invented in Germany in 1903. It is as clear as the finest glass, but softer, so that it is potentially easier to carve. It was first produced under the brand name Plexiglas. Eventually it was licensed for manufacture in many countries, almost each one using a different trade name.

Lucite became the material of choice for aircraft windshields, from the plain, flat surfaces of ordinary transport windscreens to the beautiful blown "bubble canopies" of fighter aircraft. Several of the Bauhaus sculptors worked with it in the twenties and thirties, using thin sheets of the material. None attempted to carve it, nor to see it as containing forms locked within it.

TWIST 31 (with detail)

John loved the beautiful reflective and refractive qualities of Lucite, as well as its transparency. He took these qualities in hand and became their master, carving, grinding, sawing, sanding, shaping, machining, and polishing. The sculptures he creates are active agents, with their own demands on light and on the observer. Instead of simply catching some light and turning back a lesser portion to the viewer's eye, a Safer Lucite sculpture beats light back and forth within it like a shuttlecock, passing it along at continuously varying angles as it tempers and transmutes it.

John has pulled from the Lucite womb some marvelous creations, which he has titled simply *Twist*, numbering them serially. The first one was done in 1963, and he has made perhaps one hundred altogether. *Twist* sculptures grasp and contain the full spectrum of light, visible and invisible, channeling this captured light in arcs, forms, shapes within shapes, and even lights within lights. His Lucite rods—involuted, convoluted, immobile, yet as full of movement as a hive of bees—take command and reduce both light and the viewer to optical servants. Even if the viewer remains perfectly still looking at one of the *Twist* sculptures, the mere reflexive movement of the eyes will cause it to flash and spark with a vibrant, multi-colored rainbow of changes.

The primordial, dreamlike sense of flight that all humans share, that effortless yet terrifying passage through space that has been imagined and described since the beginning of time, has never been better expressed than in John's Lucite works. If the intricate, inter-twining smoke trails of the Blue Angels and the Thunderbirds could be caught, frozen in time, and transmuted, they would be John Safer sculptures.

The series of *Twist* sculptures has another very special significance for John. His first sale—always of emotional importance to an artist—was of a *Twist* piece.

In 1969, John had given a friend, Luis Lastra, one of his early *Twists*. (Lastra, together with his partner, Ramon Osuna, later opened the Pyramid Gallery in Washington, D.C., where John had his first show.) Shortly after the gift, Lastra called John to inquire if he might sell it, saying that while this might not appear to be a gracious gesture, he thought John would surely enjoy seeing one of his sculptures sold for real money. The artist replied that he was indeed delighted at the prospect. Lastra explained that he had been visited by Anthony Bliss, then president of the Metropolitan Opera Association in New York, together with a woman, who had fallen in love with *Twist*. Bliss wished to buy it for her; Lastra agreed, with John's permission, and the first sale was consummated.

Twenty years later, John was attending an opening night at the Kennedy Center in Washington. As he stood in the crowded foyer, he heard someone say the name "Tony Bliss." He introduced himself, and asked about the sculpture. Bliss explained that the lady for

LAOCOÖN REVISITED 1975 *Clear Lucite on gray aluminum base, 71×16×16 inches.* *Collection of the artist,*

Washington, D.C.

LAOCOÖN REVISITED (details)

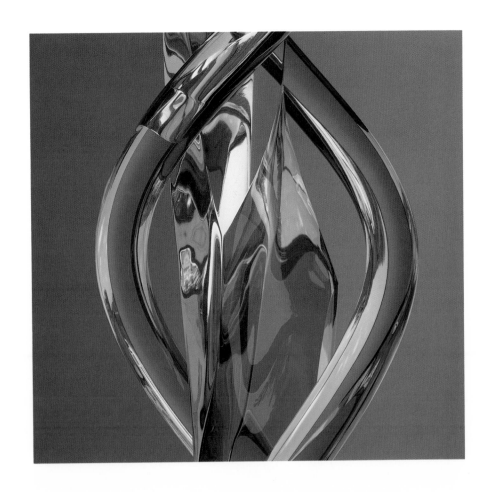

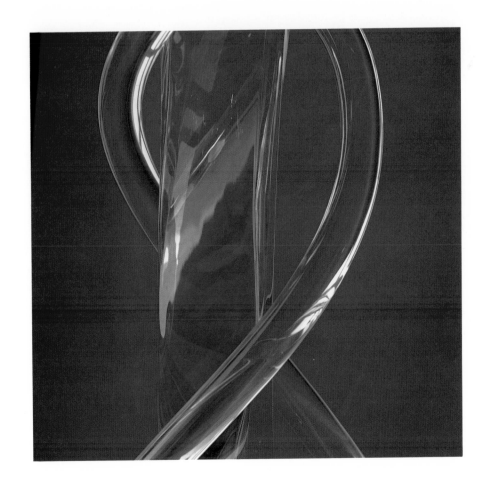

7 5

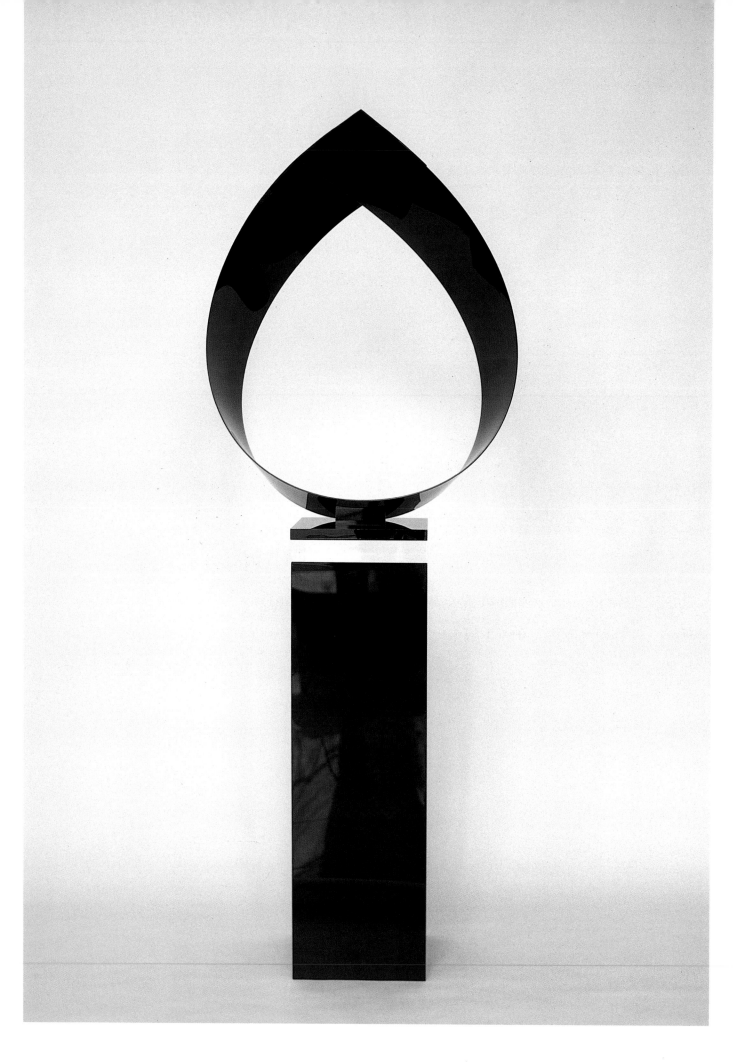

CHANDELLE 1969 *Black and clear Lucite, 73×28×12 inches.* *Collection of Mrs. June Degnan, San Francisco.*

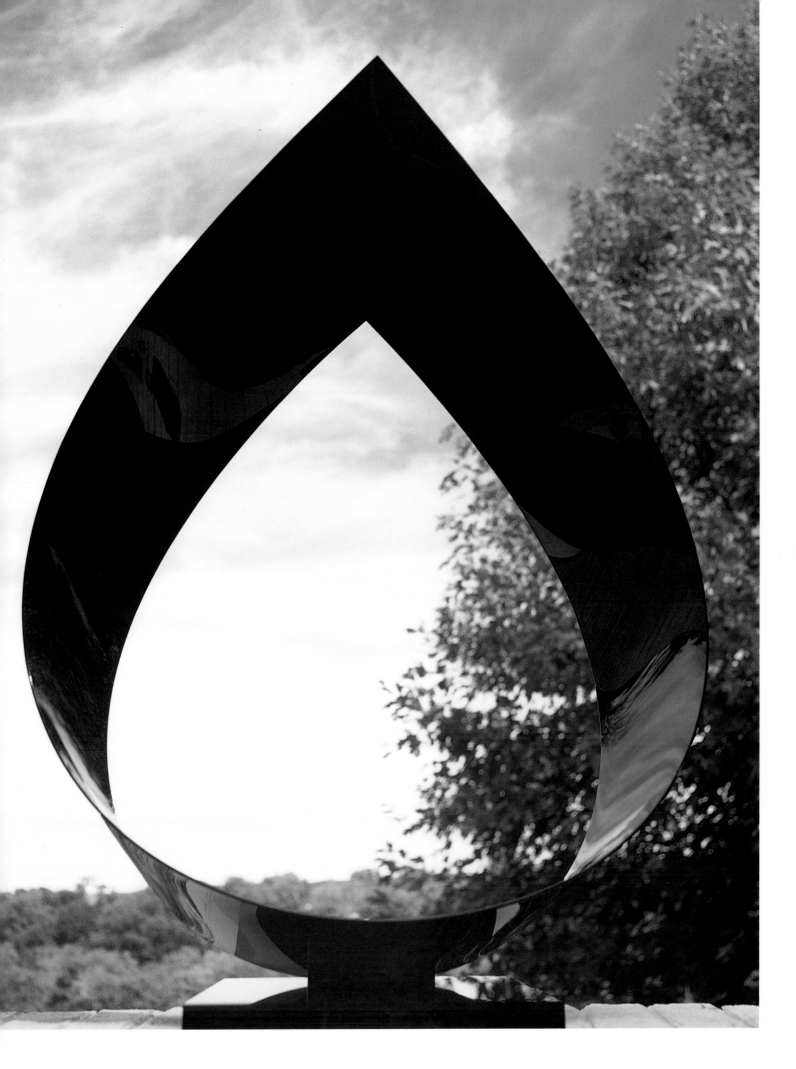

whom he had purchased it was now his wife, and that *Twist* was prominently displayed in their home.

While a first sale is a marvelous experience, there is nothing like a second sale to establish confidence, and this came in short order, with the creation of *Chandelle* (1969), the very first of John's pieces to have a theme and name involving flight. (A chandelle is a difficult flight maneuver that appears to be simple, calling for simultaneous changes of speed, altitude, and direction.)

A Lucite work over six feet tall, *Chandelle* consists of two elements: the upper is a pointed oval flame that is also part of a Moebius strip, eternally turning in upon itself, suggesting its aerial origin; the lower is a base, and the two are separated by a transparent block, placed so that the upper section seems to float in space. It was purchased by a San Francisco collector, June Degnan, and led to a long-standing friendship with the artist.

As John gained experience, and as his confidence in his capabilities grew, he began to relish the visual impact that angles and facets brought to the material. Just as the blank canvas speaks to the painter, or the blank page to the writer, clear Lucite spoke to John Safer. *Cube on Cube* (1969), a deceptively simple sculpture, can be considered a centerpiece of the early years of work in the material. It came about as John was cutting a square block of Lucite. A corner chipped; he squared it off, polished the new facet, and stood the cube of Lucite on its now-flattened corner. He liked the shape itself, but liked even more the synergy of that shape combined with its transparency, reflectivity, and refractivity. He studied this accidental shape intensively, and from it created the design for *Cube on Cube*. At first glance, this sculpture appears Minimalist in design, simply an expression of its name: one cube on top of another. But though the essential form is simple, a very complex series of patterns is created through the multiple refractions caused by light passing through and reflecting back and forth off the surfaces of the cubes. With a bit of study, one begins to see patterns within patterns, and then patterns within those, kaleidoscopic phantasms that move and change with every minute shift of the viewer's eyes. As this complexity increases, so does one's appreciation for the quality of this sculpture.

John considered the basic design of *Cube on Cube* a good one, and wanted to enlarge the work. Unfortunately, large castings of Lucite are very difficult for many reasons, not least because they are very expensive. They also tend to diminish in quality of pureness and transparency in direct ratio to their size. John saw that this problem could be overcome by linking together a series of smaller cubes. As he experimented with this idea, he realized that his new design of interlocking cubes achieved far more than would have been accomplished in a casting of a single large cube. The design, the lines, the play of light all added up to something much greater than the sum of the parts.

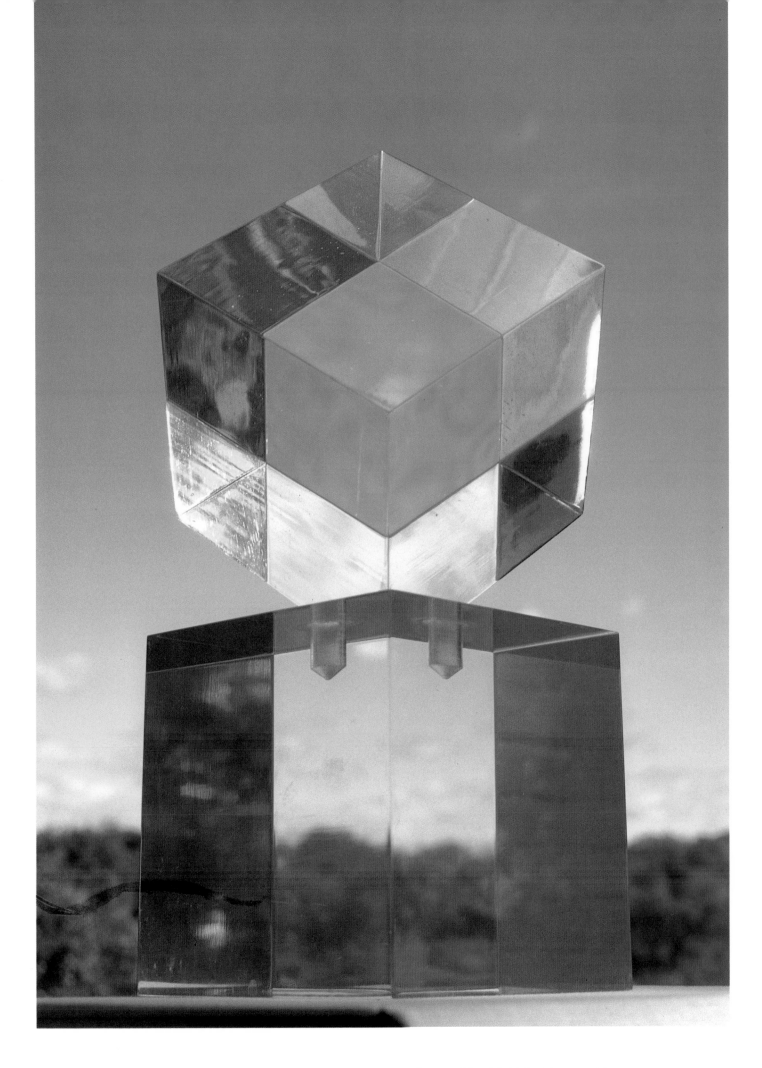

CUBE ON CUBE 1969 *Clear Lucite, 15×6×6 inches.* *Collection of the Philadelphia Museum of Art.*

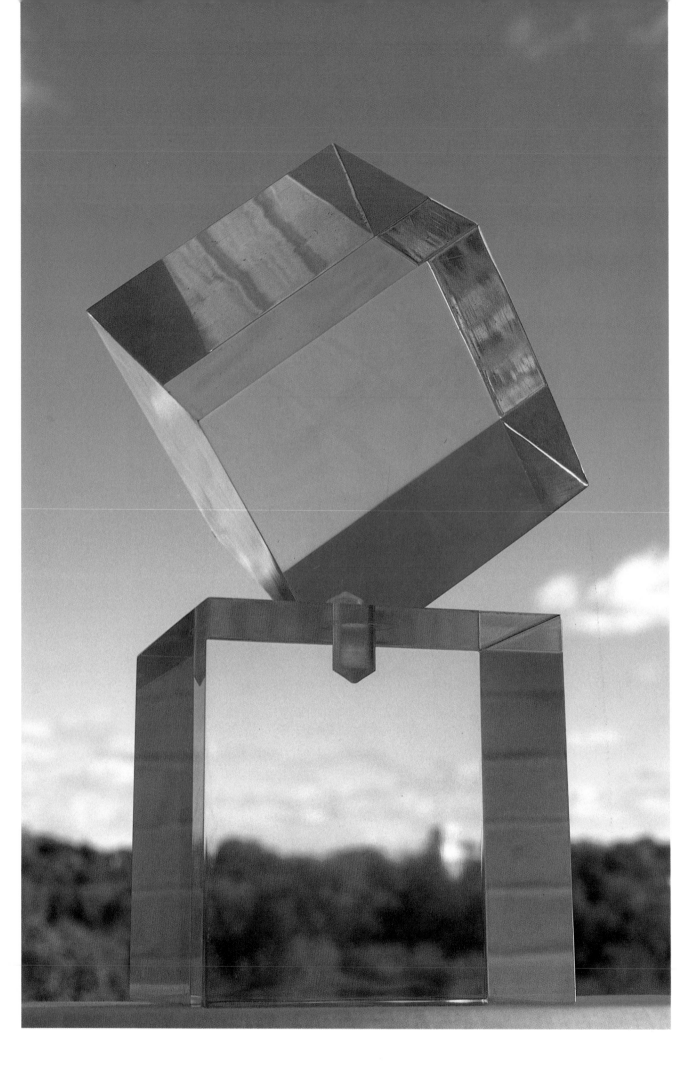

CUBE ON CUBE (with details) 8 0

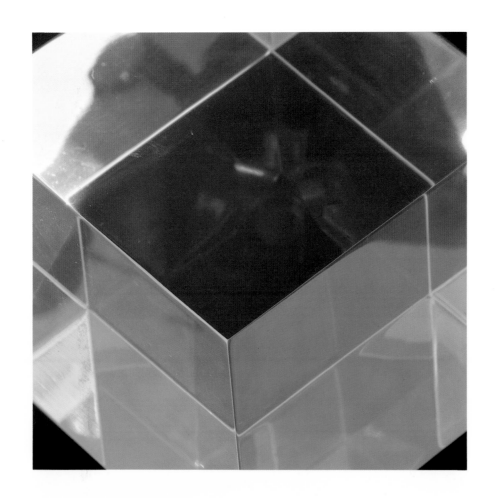

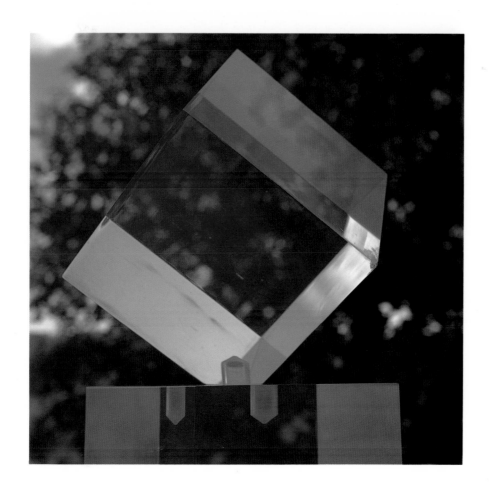

He synthesized his findings by expanding the basic concept of *Cube on Cube* into a series of five sculptures, each titled *Multicube,* and numbered consecutively. The components varied in size from three- to six-inch cubes.

All of the *Multicubes* share and illustrate the essence of Safer sculpture, the remarkable effect upon light of the lines of the sculpture and its material. A single ray of light ricochets within a *Multicube* like a rifle shot in a canyon—there is the initial sharp crack, the bullet's whine, and then the impact, all echoing, echoing. The single ray of light follows a wild, reverberating path from one facet of the sculpture to another, until the entire sculpture is ringing with scattered light.

The latest version, *Multicube V* (1969), is a complex of Lucite and brass, eleven feet tall, that might have been conceived as the centerpiece for some intergalactic cathedral. It is a brilliant association of cubes and plates that seem to merge and separate continually as it hangs suspended in space. It is sited in the lobby of an office building with a glass front, and a sudden spray of lights—perhaps from the headlights of a passing car—has a spectacular effect, setting off a firestorm of reflections within the piece, producing a Fourth-of-July display of bouncing, buoyant light.

The essence of creation is change. And so, as the years have passed, John's sculptural concepts have developed. He began to envision new free-form images, flaming upward, that would embody his ideas of beauty and harmony and enable him to give expression to his essential views of humanity and its relationship to the universe.

MULTICUBE V (with detail) 1969 *Clear Lucite on patinated bronze base, 11×3×3 feet. Collection of Market West Associates, Washington, D.C.*

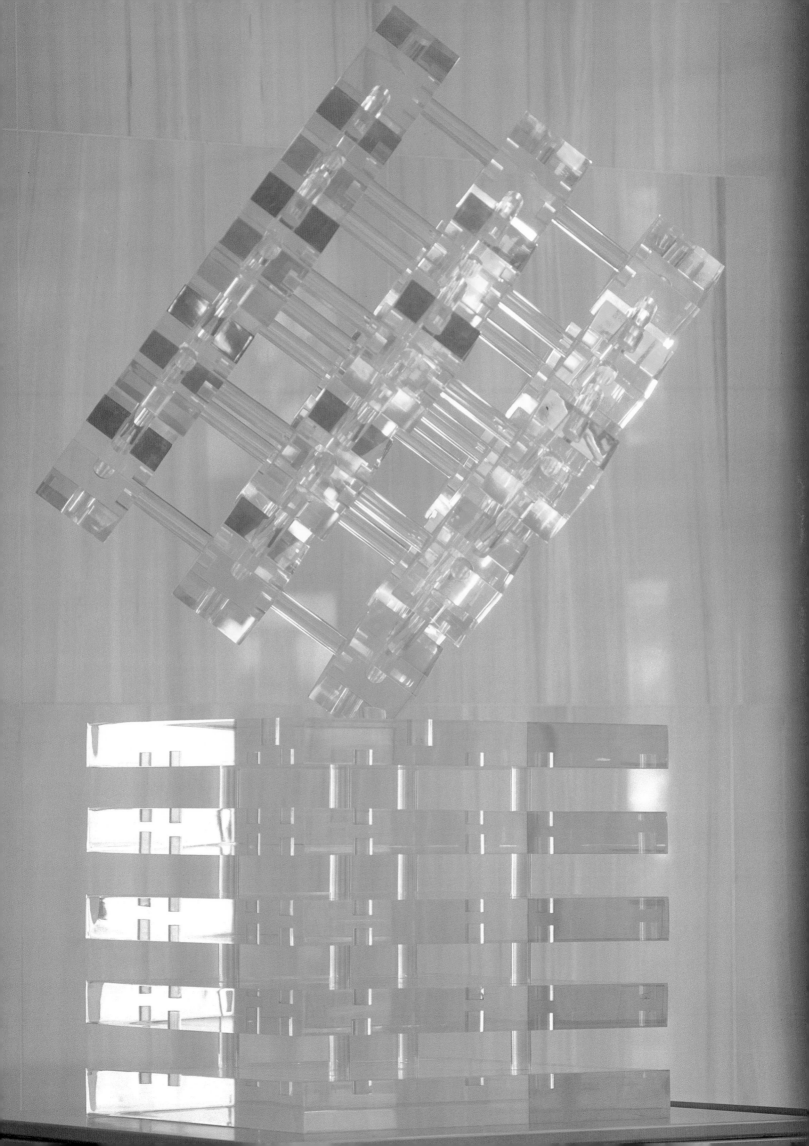

MULTICUBE V (details)

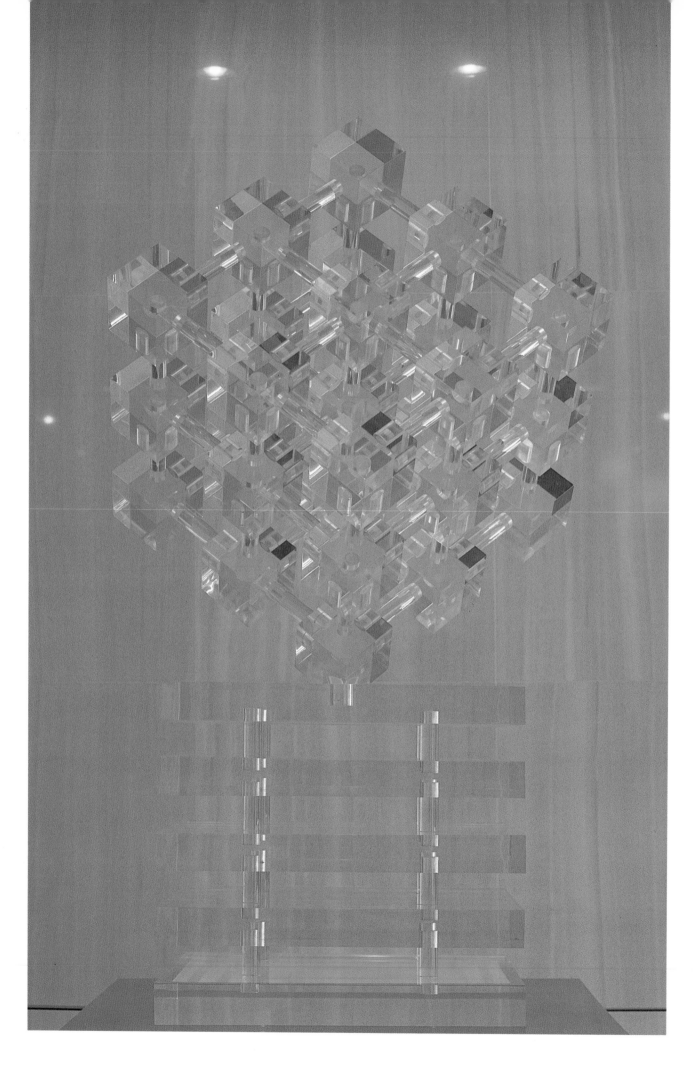

MULTICUBE V

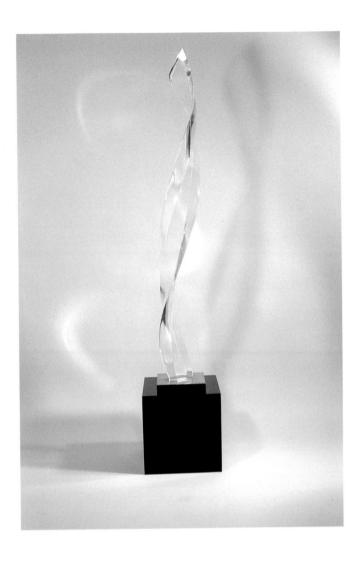

One of his first essays in flamelike forms of Lucite was *Janine* (1971), a simple and graceful work, which John named for his daughter. Although it is an early piece, it has an inherent wholeness and balance, and in a sense reaches a design end-point.

Another early Lucite work is *Cinquantaine*. Some have said that it leaps like a Saracen's sword from its brass plate. I see it differently, as an elegant turbine blade plucked ringing from a gigantic, crystal jet engine. It was created as a joint birthday present for two of John's closest friends, Arthur Mason and Edward Brylawski, for their fiftieth birthdays, which they celebrated together. John, who can never resist an opportunity for wordplay, gave them the sculpture fifty-fifty (as the French title suggests). As a result, the two friends now share the sculpture, each one keeping it for six months of the year.

Mason and his wife, Jane, played another important role in John's career as a sculptor. They commissioned *Wind* (1987), a magnificent nine-foot-high polished-steel work that normally stands in their Washington townhouse, surrounded by their world-renowned collection of turned wood bowls. *Wind* was one of the focal points of a 1989–90 European tour of John's works.

WRAITH 1978 *Clear Lucite on polished brass base, 85 × 12 × 12 inches.* *Collection of Mr. and Mrs. Herbert S. Ascherman, Potomac, Maryland.*

JANINE (with details) 1971 *Brown Lucite on polished brass base, 43×6×6 inches.* *Collection of the artist, Washington, D.C.*

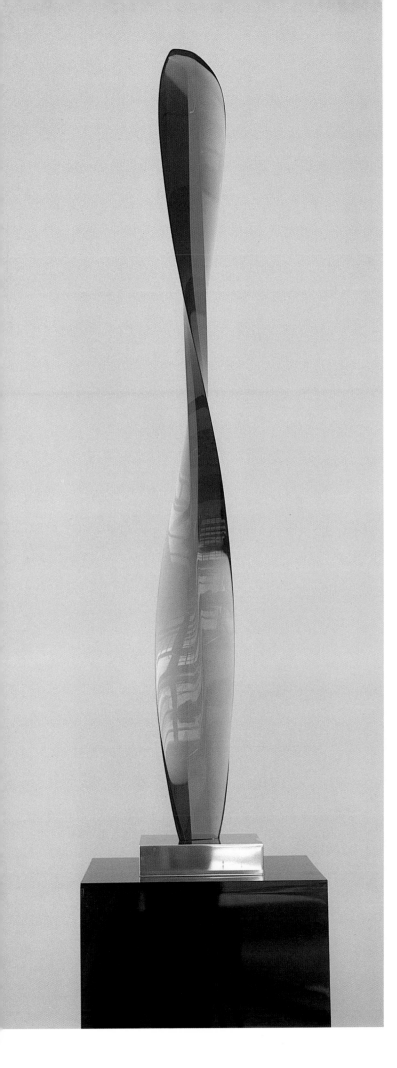

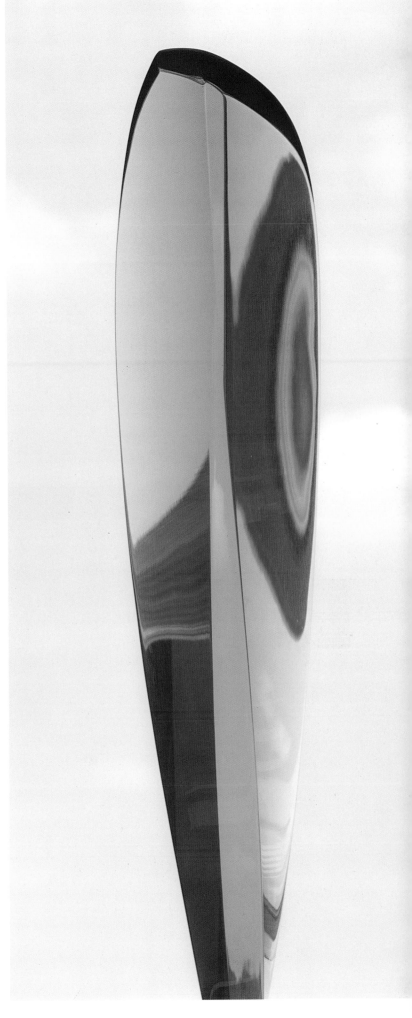

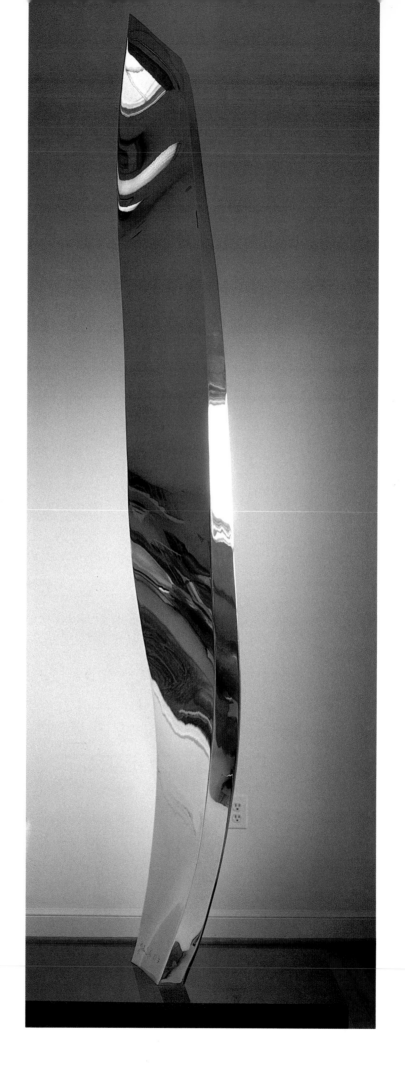

WIND (with details) 1987 *Polished steel on black granite base, 9×2×2 feet.* Collection of

Mr. and Mrs. Arthur Mason, Washington, D.C.

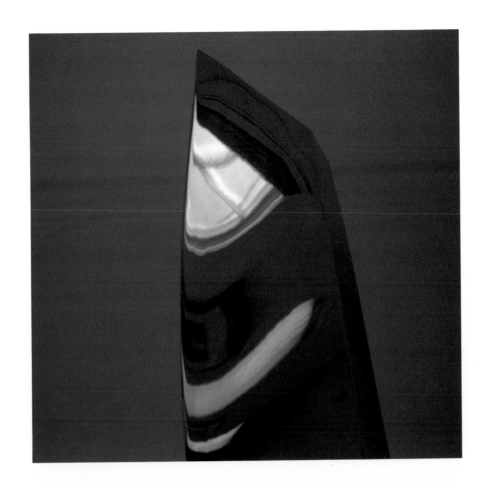

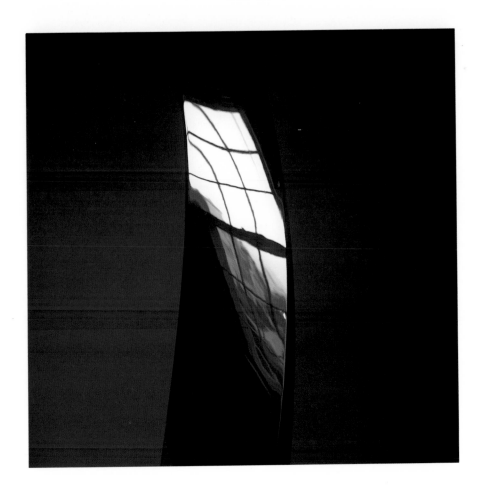

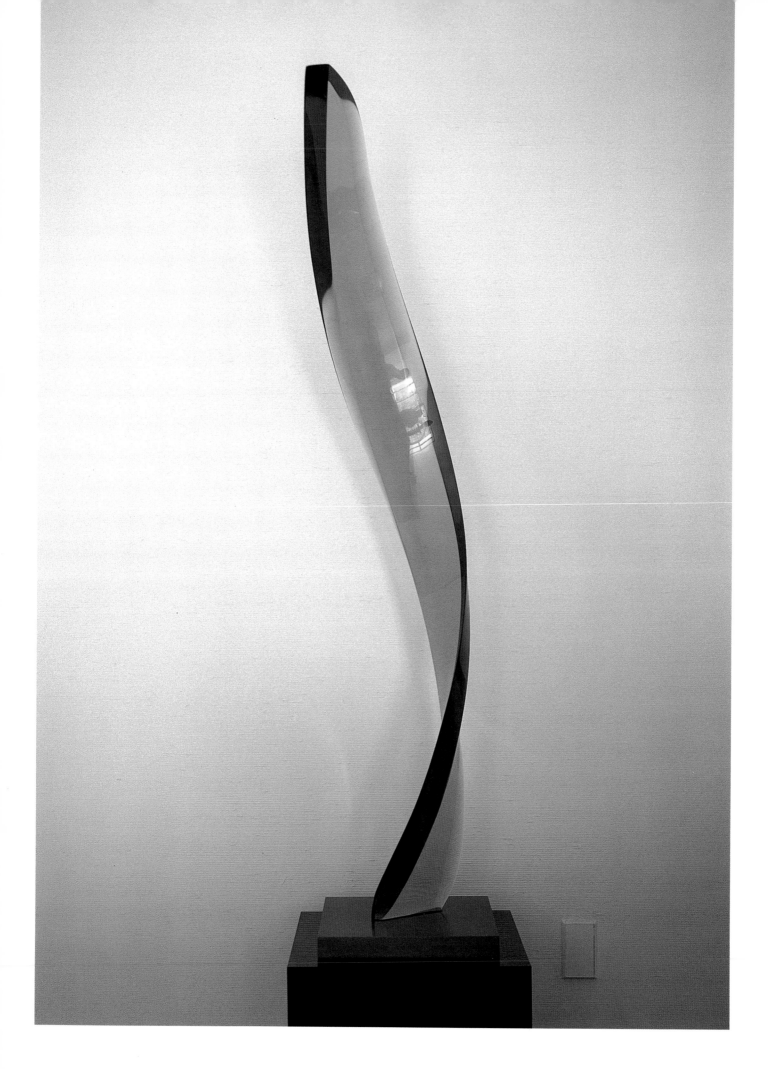

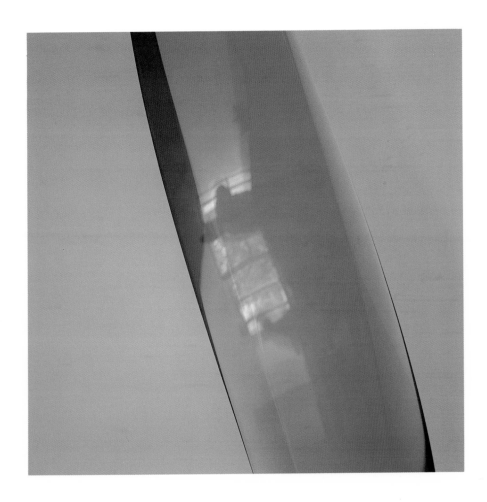

Still another early flame piece, *Crystal* (1970), was displayed in the artist's first show. John himself feels that he may never have done anything better. Other flamelike, dancing Lucite works followed, such as *Mistral* (1980), *Serpentine* (1980), and *Night Flight* (1974), named for the title of one of Saint-Exupéry's books. When I queried John about the use of a Saint-Exupéry title for one of his finest sculptures, he told me that he felt a great spiritual kinship with the flyer, and had chosen the title with affection, to express a relationship between his work and that of Saint-Exupéry.

In these pieces one senses the full emergence of John's philosophy that life is good and that art should work to draw people closer together. These sculptures are truly individual flames, leaping upward, striving, sometimes coiling, but never recoiling or diminishing.

MISTRAL (with detail) 1980 *Brown Lucite on gray aluminum base, 59×16×16 inches.* *Collection of the artist,*
Washington, D.C.

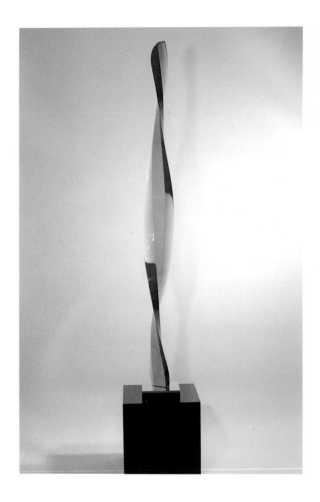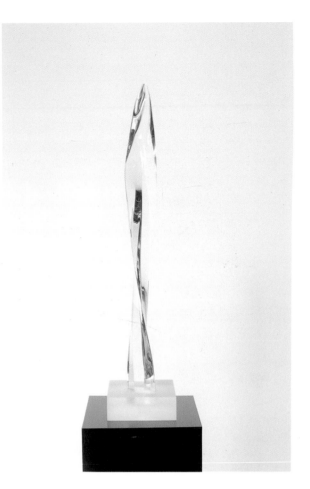

As John's sculptural vision changed and grew, he began to feel a desire to create shapes that would provide the same volatile play of light-created images, the same sparkling brilliance to the eye, yet with the shape itself, rather than the light play within it, dominant. So he began to work in nontransparent materials, primarily highly reflective bronze and steel.

The mechanical skills John employed in creating his Lucite works translated with remarkable ease to metal. *Bauhaus Remembered* is a twenty-inch-high sculpture finished in 1974. The piece is a labor of love and respect for the circle of European designers who took their name from their first building, and acknowledges their flirtation with Lucite. They had been driven out of Germany and Austria by Hitler, as practitioners of "degenerate" art. John sought to recapture the feeling the Bauhaus designs had originally invoked in him, with their clean lines, austerity, good craftsmanship, and, always, their feeling for beauty.

Bauhaus Remembered was not cast from a model, but hand-machined in brass and then chrome plated. In this, his only use of chrome-plated brass, the artist sought the silky, highly polished finish that would be appropriate to the piece's intention. In later works, to

Top left: NIGHT FLIGHT 1974 *Gray Lucite on polished brass base, 73×12×12 inches.* Collection of the artist, *Washington, D.C.*

Top right: CRYSTAL 1970 *Clear Lucite on frosted Lucite base, 29×6×6 inches.* Collection of *Mr. and Mrs. Robert Rosenthal, Washington, D.C.*

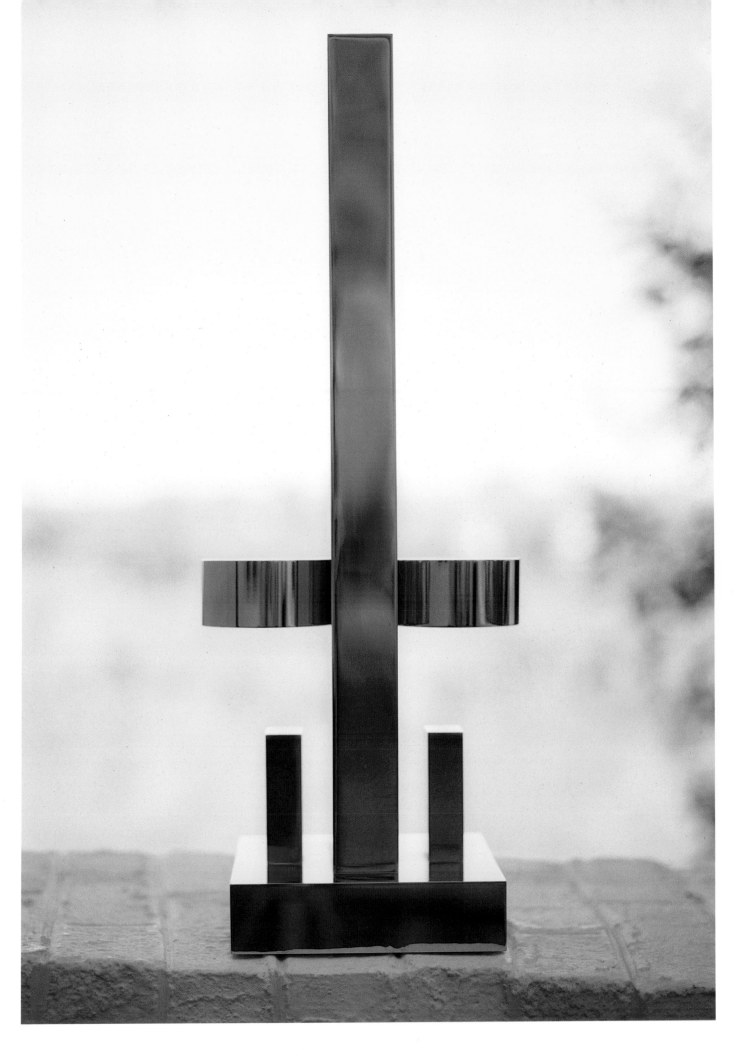

9 5 BAUHAUS REMEMBERED 1974 *Chrome-plated polished brass, 20×8×6 inches.* *Collection of the artist,*
Washington, D.C.

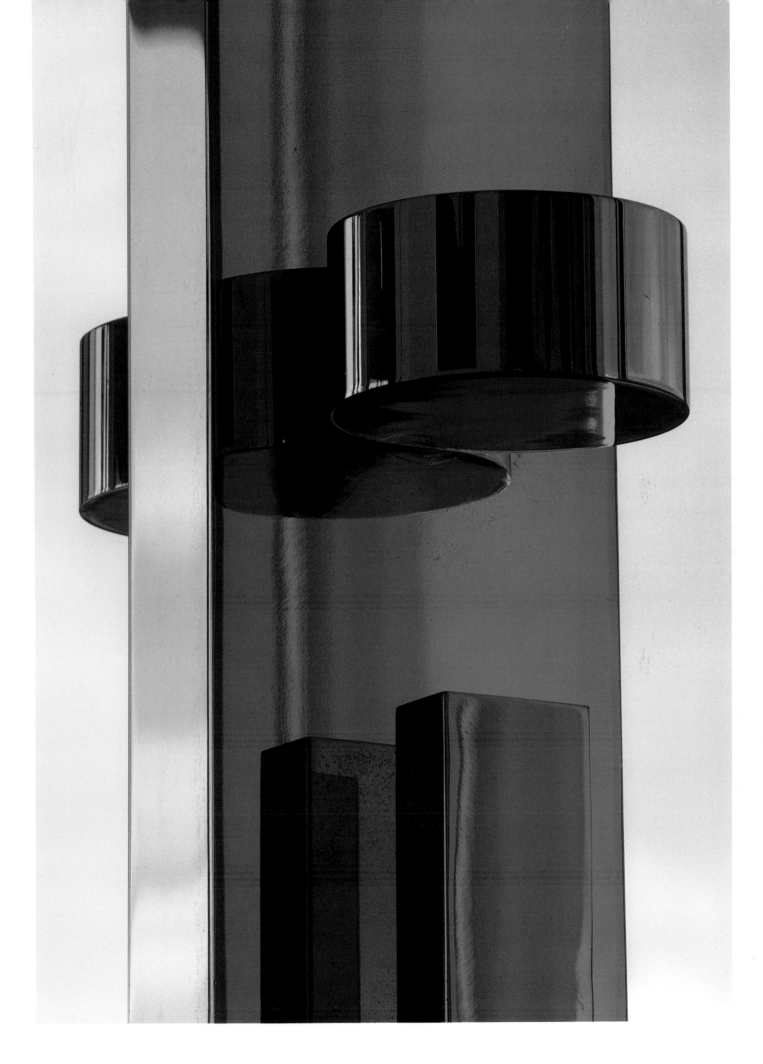

BAUHAUS REMEMBERED (details)

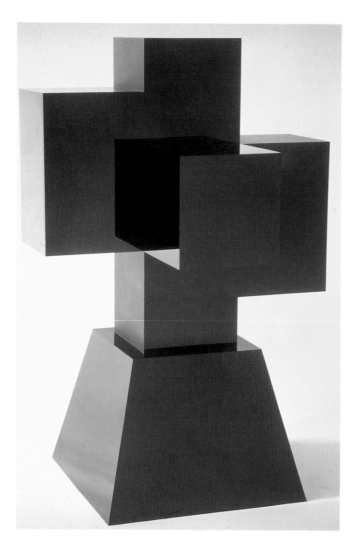

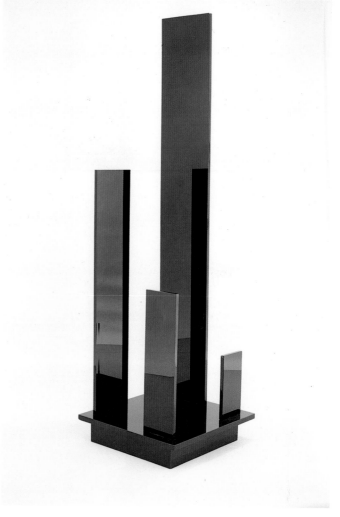

Above left: SYMBOL I 1970 Black Lucite, 72×48×48 inches. Collection of the artist, Washington, D.C.

Above right: TIME FRAME 1972 Black Lucite, 80×24×24 inches. Collection of the artist, Washington, D.C.

Opposite page: TERMINUS 1972 Brushed brass, 20×14×8 inches. Collection of the High Museum of Art, Atlanta.

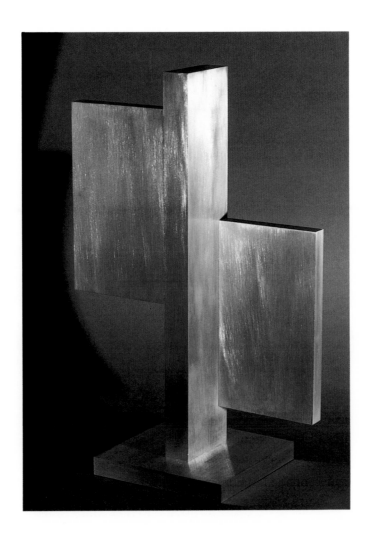

attain a similar finish, he turned to high-chrome stainless steel, in which, by the operation of
natural forces, the chrome forms a skin over the steel. The difference in appearance is a very
subtle one, but in these nuances are found the essence of art.

A series of related works followed. One was *Golden Horn* (1983), a simple,
flamelike piece of polished bronze that is pure grace in upward motion. It was created out of
affection for his close friends, Alma and Joseph Gildenhorn. Gildenhorn is currently the
American ambassador to Switzerland, and he and his wife were the hosts of an exhibition of
Safer sculpture in the ambassador's residence, part of the 1989–90 tour. *Golden Horn* is both
an apt, descriptive name and a bit of Safer wordplay.

The concept of the *Pathway* group of sculptures is a deceptively simple design,
an upward curve of polished stainless steel, starting as a flat ribbon and tapering to a point. (It

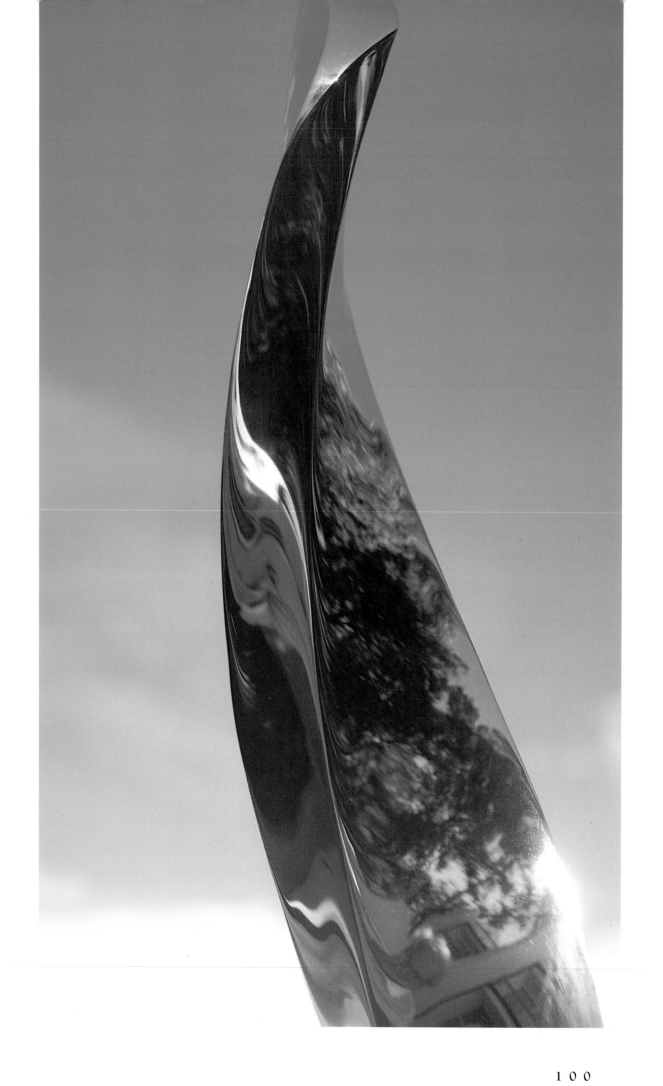

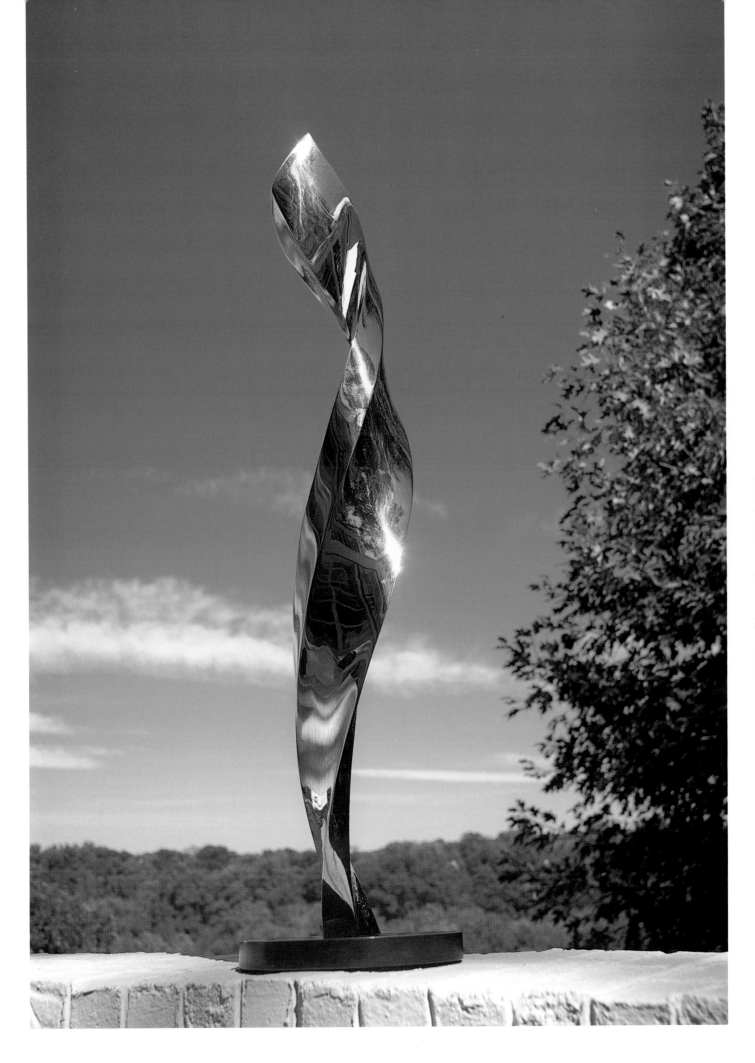

GOLDEN HORN (with detail) 1983 *Polished bronze on patinated bronze base, 42×10×10 inches. Collection of Ambassador and Mrs. Joseph B. Gildenhorn, Bern, Switzerland.*

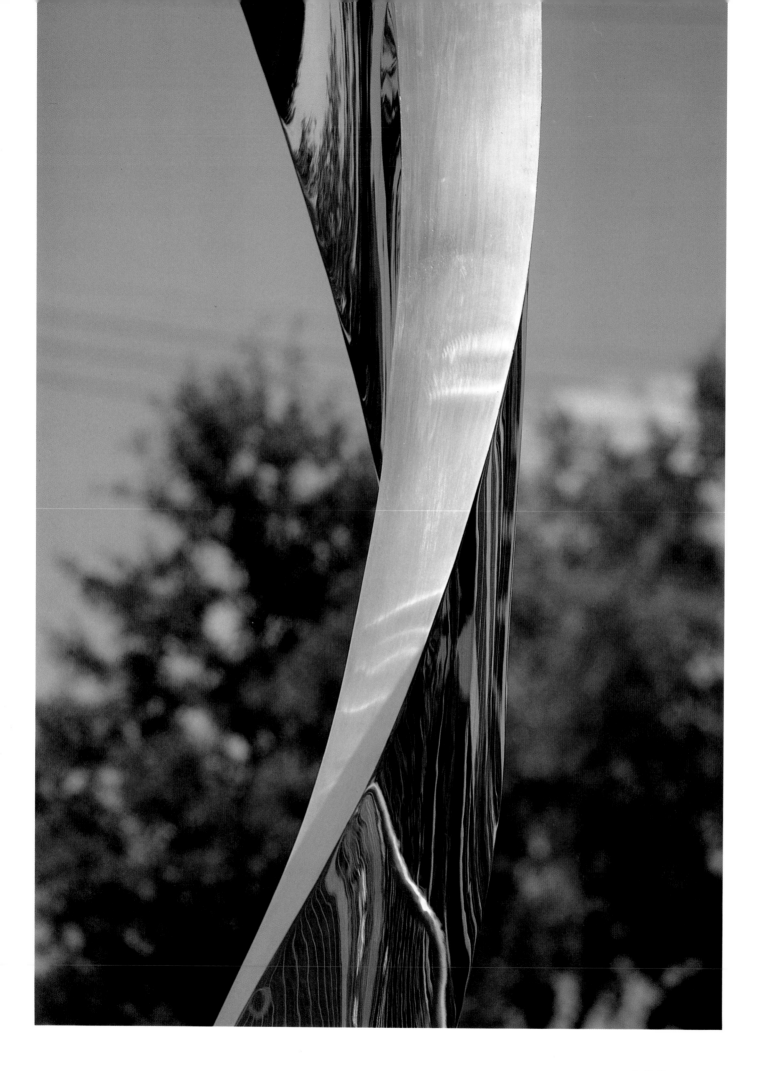

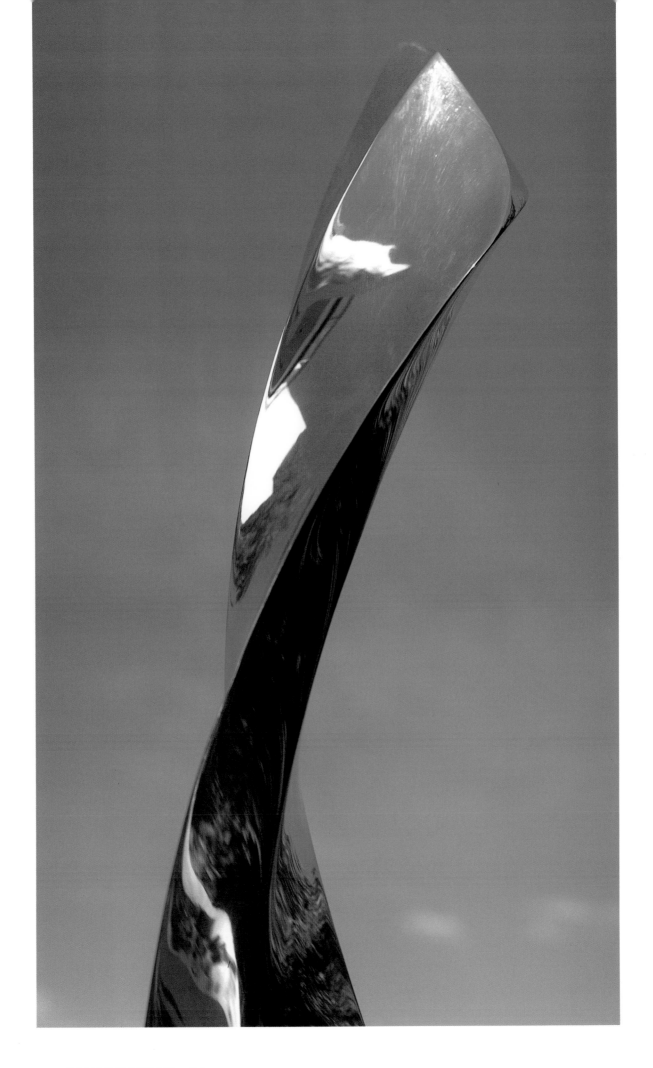

GOLDEN HORN (details)

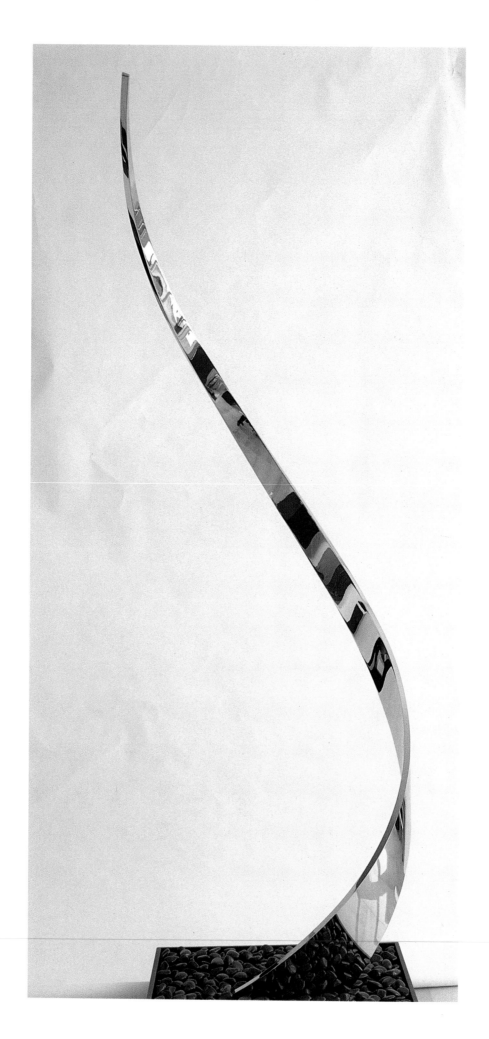

PATHWAY II (with details) 1990 *Polished steel on black granite base, 10×3×3 feet.* Collection of the
American Hospital, Paris.

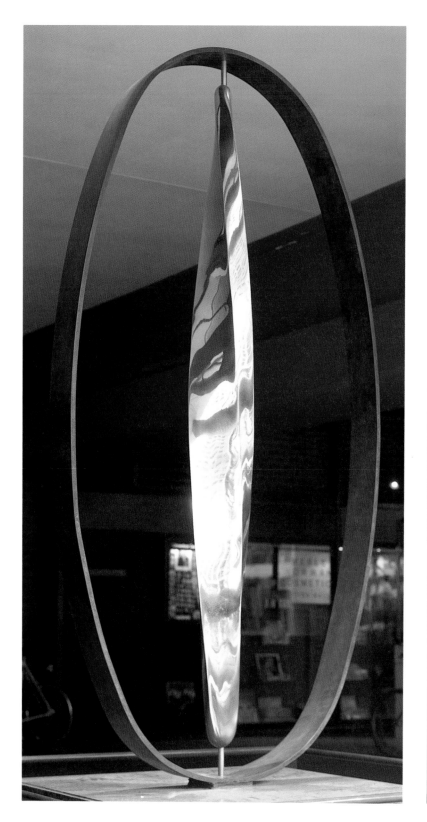

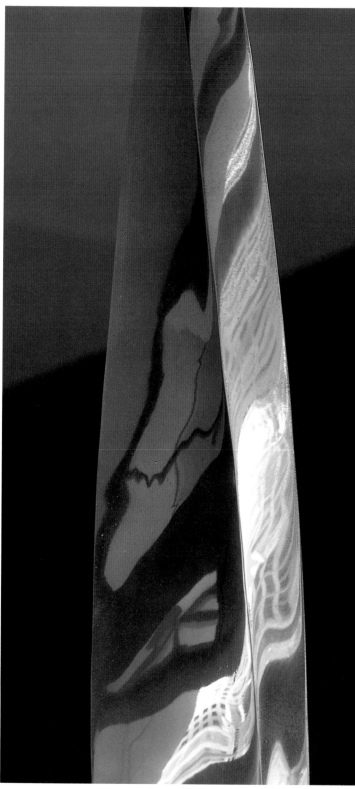

LIMITS OF INFINITY III (with detail) 1979 *Polished and patinated bronze on brown granite base, 12 × 3 × 3 feet.*
Collection of the George Washington University, Washington, D.C.

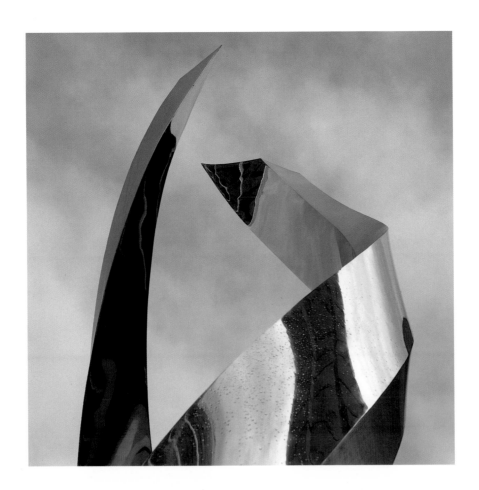

presents two faces to a pilot's eye: on the one hand, it may represent a vertical climbing turn, one of the most beautiful and graceful of aviation maneuvers; on the other, it may represent a penetration of weather on an instrument approach, starting at some distant point and following a pathway to the safety of the runway.) *Pathway I* was done on commission for the garden of Joan and Gerald Greenwald, where it forms a wonderful centerpiece. John felt that it had great potential as a larger sculpture, so when he received a request several years later for a sculpture to fit a particular setting, an enlarged version of it immediately came to mind.

 The client was the late Judith Miller, a woman prominent in Washington for her philanthropy and business acumen, who was also a noted art collector. She and her husband, Gerald, had commissioned *Limits of Infinity III* (1979) to stand in front of a building on Connecticut Avenue in Washington. Several years later, after Gerald Miller's untimely death, his wife and their son Stuart had commissioned the striking eighteen-foot-tall polished-steel sculpture *Interplay IV* (1987) for another Miller building, Millcourt Center, in Roslyn, Virginia, as a memorial. Miller was a close friend, and I believe John's affection for him is apparent when one stands before *Interplay IV* and sees it in perfect harmony with its surroundings.

INTERPLAY IV (detail) 1987 *Polished steel on black granite base, 18×6×6 feet.* *Collection of the Gerald and*
Judith Miller family, Roslyn, Virginia.

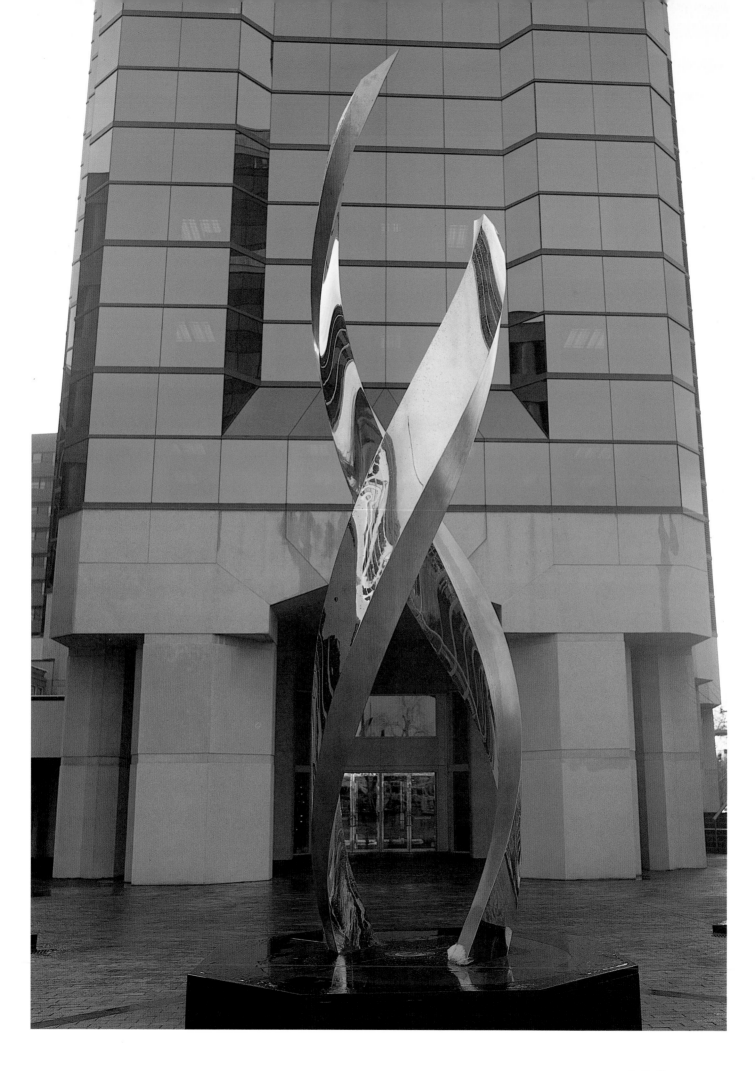

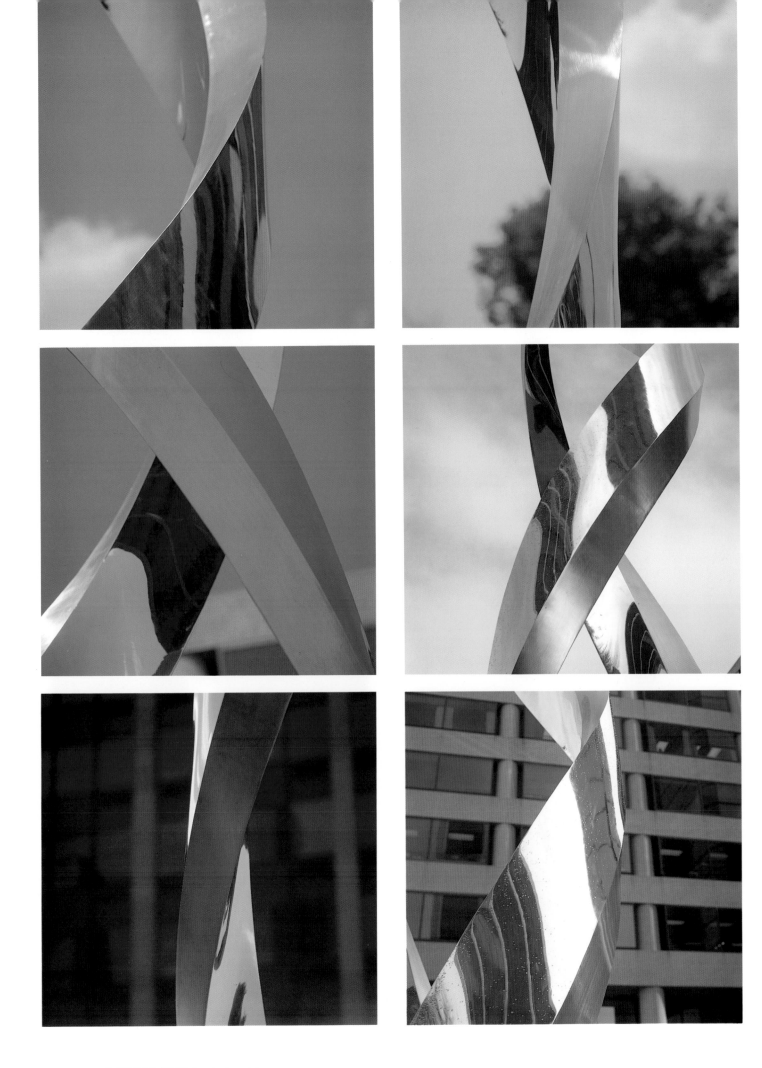

INTERPLAY IV (with details)

The setting for *Pathway II* was the Millers' waterfront home in Palm Beach, Florida. Only rarely does an artist come across a setting that seems to have been designed with his work in mind. *Pathway II* is now a perfectly set gem, outlined against the sea.

Still another casting of *Pathway II* (1990) is on the grounds of the American Hospital in Paris. It was placed there after John's 1989–90 European exhibition, which traveled under the aegis of the U.S. Department of State. The tour was the brainchild of Lee Kimche McGrath, director of the Art in Embassies Program. John had executed a second casting of *Pathway II* for this tour. The Paris show was held in December 1989 at the Espace Pierre Cardin, jointly sponsored by Pierre Cardin, the fashion designer and industrialist, and the American ambassador to France, Walter Curley. Attending the opening was the chairman of the board of the American Hospital in Paris, N. Victor Dial. Dial felt that the hospital must have the sculpture.

In many ways the *Pathway* designs represent the essence of John's striving for simplicity, purity, beauty, and clean line. I look at their shining, soaring curves, with their expression of perfection in motion, and wonder if this is not the distillation of that timeless desire to fly through space that lies deep within all of us. It is but a small step for the imagination to see in *Pathway* the circular approach of the space shuttle, returning home from beyond the atmosphere.

IV A Smile from Kelly Johnson

JUDGMENT (detail) 1979 *Patinated bronze on concrete base, 15×20×20 feet. Collection of Harvard Law School, Cambridge, Massachusetts.*

JUDGMENT

The sculpture *Judgment* (1979), the result of a straightforward conception and an almost interminable gestation, is a fifteen-foot-high bronze on the campus of the Harvard Law School. A mellow, imposing piece, it has a long and complex history.

Judgment started as a nameless sculpture created in limbo. The work is composed of three elements, and John was initially concerned not only with finding the right shape for each element but also with ensuring that their internal spatial relationships be in balance. As he describes it:

A general sculptural aim that underlies many of my works is the creation of a tension within the shapes, and then the resolution of that tension. As *Judgment* began to take shape, I realized that I was working in two directions. The shapes themselves, as they began to emerge, were those half-perceived images one sees when one stares into a fire or watches sunlight flickering on the ocean's waves. Since all life emerged originally from the ocean, and for millennia generations of our ancestors sat in front of campfires, I feel these shapes have a universality that binds us all together. I believe that humans from the Kalahari to the Arctic will have similar responses to these basic stimuli. I also felt that I was creating a symbol of the law, something essential to all societies, powerful, majestic, secure—and yet always with a sense of menace.

But the road from working out the balance of a personal sculptural project to its installation at a public site can be long. This one began with a letter to John from the editor of the *Harvard*

Law School Alumni Bulletin in the mid-1970s. She had seen an Associated Press dispatch to the effect that John Safer, an alumnus of Harvard Law School, had created a sculpture that President Gerald Ford had presented to King Juan Carlos of Spain as a gift of state. To the editor, a Harvard lawyer making sculptures suggested a news item. She asked the artist for a bit of information on the sculpture as the basis for an alumni note.

She was intrigued by what she received from him, and after she had published the item asked for more information so that she could do a cover story in the *Alumni Bulletin*. In time the article was published and John received yet another letter expressing interest in his sculptures, this one from Albert Sacks, dean of the law school, who suggested that it would be appropriate for the Harvard Law School to have one.

John offered the law school an unspecified work. The dean accepted it and turned the matter over to the chairman of the Harvard Law School Art Committee. Next John received a call from the chairman, Bernice Loss, also a sculptor, as well as the wife of one of the law school's most distinguished professors.

Loss asked for the specifications of the sculpture John intended to donate. He explained that he envisioned a cast-metal work several feet high, weighing about twenty pounds.

There was a silence. At length Loss responded that she would be delighted with such a sculpture, but that theft and vandalism were so rife on campus that she could not guarantee its safety. She suggested that the sculpture might be placed in the faculty dining room with some degree of security. Would this be acceptable?

It would not. John had intended his gift for the students. To have it locked away where they would never see it made the entire concept of the gift pointless. The matter seemed to have come to a halt.

A year later, John was taking a breather from the installation of an exhibition of his work at the David Findlay Galleries in New York. As he walked in Central Park he passed a massive bronze sculpture and it occurred to him that if such a work could survive in Central Park, a Safer sculpture, similarly scaled, could survive on the Harvard Law School campus. He realized that, appropriately enlarged, his original, tripartite sculptural design would fit well into the law-school ambience. If it were done on a massive scale, its size and weight would ensure its survival. Indeed, its theme and concept seemed to have been created specifically for the law school.

John called Loss and told her of his great inspiration; it received a cool reception. Thinking about it later, he said, "I forgot that one can't see a sculpture over the phone." Once again, the project was off.

Yet the quality of his work persisted in Loss's mind. A few months later she visited Washington and asked to see some of Safer's sculpture at first hand. As he showed her his work, she stopped before the maquette for *Judgment,* saying simply, "Oh, we must have that!" The project was back on.

John happily told her that since he had a real affection for Harvard Law School, he would contribute the design and the model and would supervise the fabrication of the sculpture. All he needed from her, he explained, was the cost of fabrication, which he estimated at approximately fifty thousand dollars. Once again there was an expressive silence. The law school budget for sculpture was zero. The project was off again.

Several months passed, and John received an invitation to a dinner in honor of a new senator from Nebraska, Edward Zorinsky. Two of Zorinsky's principal backers, Frederick Cassman and James Wolf, were flying to Washington. Both were old friends and had been classmates of John's at Harvard. They had both read the article in the *Alumni Bulletin* and wanted to see his work. John gave them a tour of his home gallery.

Not unexpectedly, they suggested that the Harvard Law School should have a Safer sculpture, and proposed that it be a gift of their class on its upcoming thirtieth reunion. The project was on once again, and in June 1979 *Judgment,* a five-ton bronze outdoor sculpture, was presented to the Harvard Law School as a gift of the class of 1949. There it stands today.

John, like all artists, has his own inner sense of the symbolism of his work. He does not share my view of *Judgment* as expressing imagery of flight. But he and I cannot diverge greatly in our interpretation of another of his works, *Challenge* (1988). This piece derives from his concept of motion through space, and was done as a memorial to Christa McAulliffe, who lost her life in the terrible explosion of the space shuttle *Challenger* in 1986.

The genesis of *Challenge* came through a Washington real-estate developer, Mark Vogel, who commissioned John to create a sculpture for the lobby of an office building in Bowie, Maryland. The commission was not specific; John was asked simply to create a work suitable to the building's atrium. He had been working on the model for this piece for about six months when the developer suggested a change in the theme of the sculpture from that of a general work to that of a memorial to McAulliffe, who had received her master's degree in education from Bowie State College. She had taught in Bowie for several years, a fact that had been a major factor in her selection as a member of the *Challenger* crew.

John was somewhat taken aback by the idea of scrapping a sculpture he had been working on for six months. It was practically complete, and he had invested in it a great

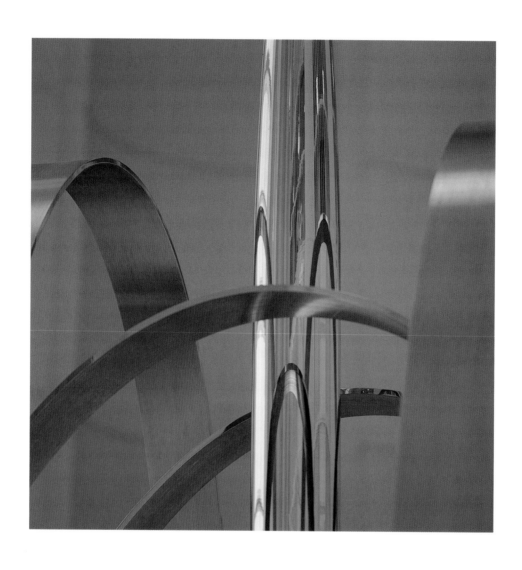

CHALLENGE (with detail) 1988 *Brushed and polished steel on black wood base, 15×10×10 feet.*
Collection of Bowie New Town Center, Bowie, Maryland.

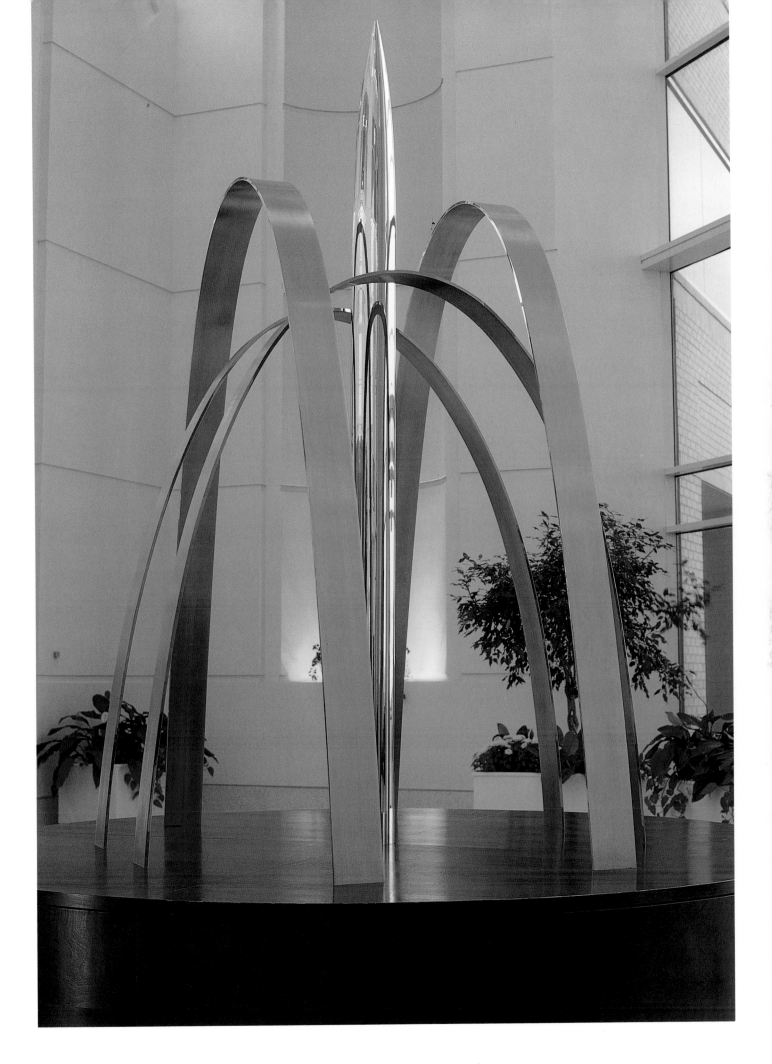

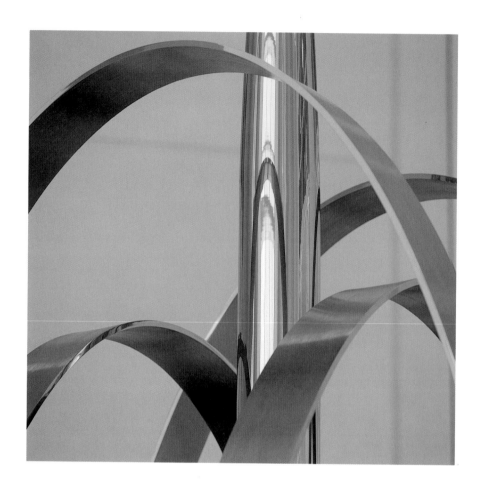

deal of time, inspiration, and energy. Naturally, his first reaction was one of disappointment and irritation, but this quickly passed as he conceived almost instantly the design for a memorial sculpture to McAulliffe, with the title *Challenge*.

The result is breathtaking. *Challenge* is clearly one of John's finest works. It is a series of overlapping steel arcs surrounding a shining needlelike shape, conveying the images

CHALLENGE (details)

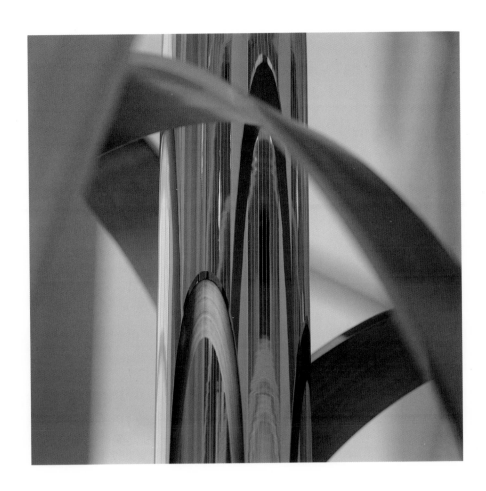

of spacecraft and space travel, and at the same time symbolizing both our hopes and our aspiration to overcome gravity and leave the surface of our planet.

At the dedication, Christa McAulliffe's mother embraced John and said, "When I walked in and saw the sculpture, my heart stopped for a moment; this is what Christa would have wanted." Few artists receive so great a reward; none could ask for more.

CHALLENGE (detail)

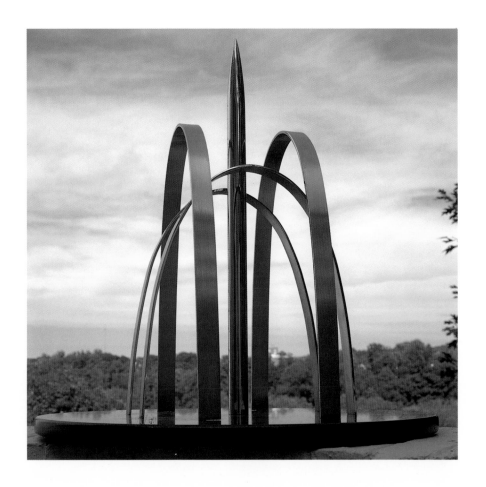

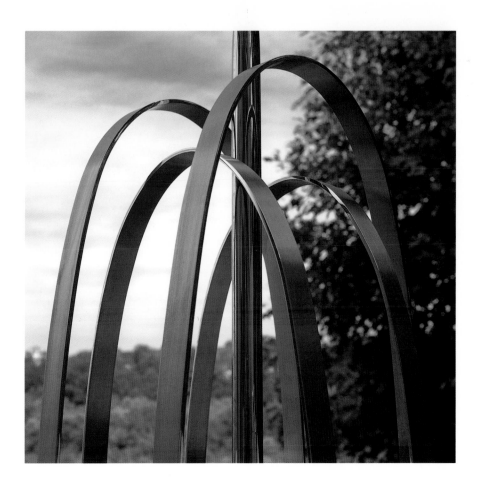

CHALLENGE (*maquette;* with detail) 1988 *Brushed and polished steel on black granite base, 20×20×20 inches.*

Collection of Ambassador and Mrs. Richard Gelb, Brussels.

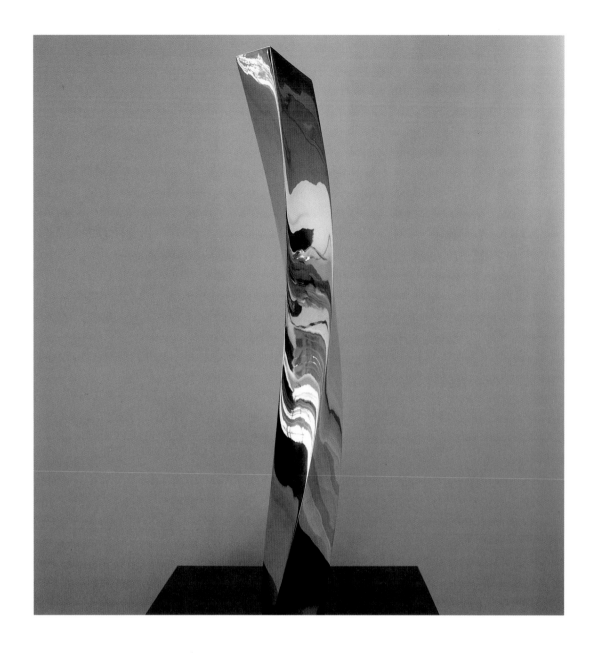

Other John Safer sculptures have elicited a similar response and fulfilled needs that transcend even art. *Symbol of Courage* (1986) stands in the Lombardi Cancer Clinic at Georgetown University Hospital in Washington, D.C. John had been asked by the art patrons Bernard and Sarah Gerwirz (who are also collectors of his work) to create a sculpture that would symbolize Vince Lombardi, whose zest for life and gallant struggle against death had captured the imagination of the world. Like some of John's other work, this sculpture was also to be executed in miniature versions, to be awarded yearly by the clinic to people connected with athletics who have shown courage worthy of Lombardi in fighting cancer.

SYMBOL OF COURAGE (with detail) 1986 *Polished bronze on black granite base, 31×8×8 inches. Collection of the Lombardi Cancer Clinic, Georgetown University Hospital, Washington, D.C.*

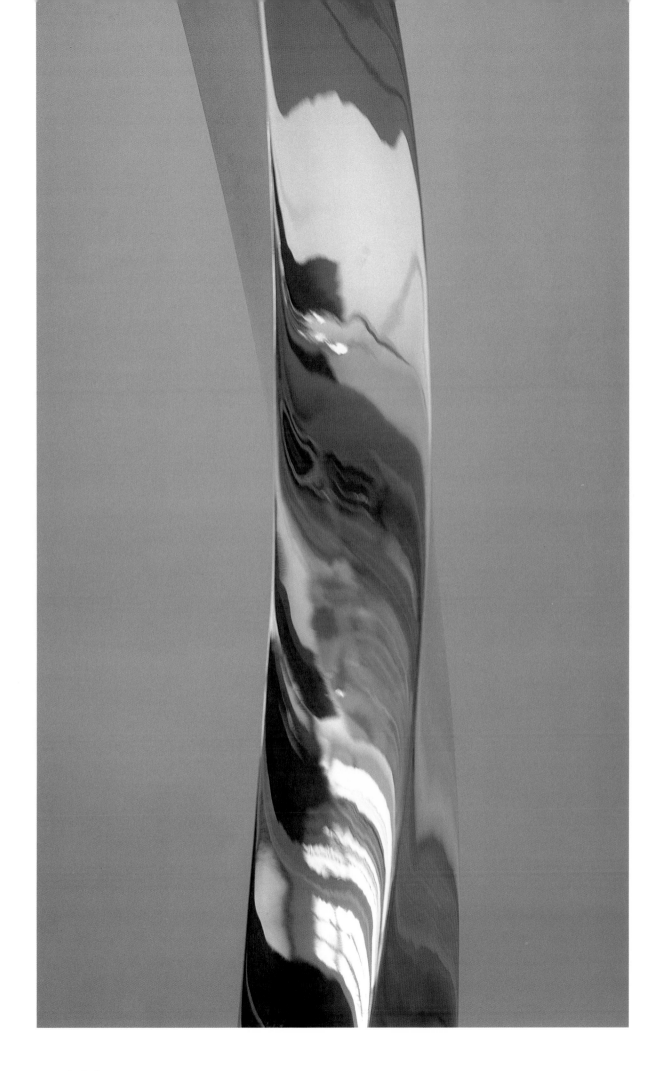

John is comfortable accepting assignments to create works to fulfill specific functions. He cites a letter that Leonardo da Vinci wrote to the Duke of Milan, applying for a position. Leonardo said that he could draw a portrait as accurately as anyone in Europe, that he was a very competent sculptor, and was capable, if required, of drawing plans for a palace or a fortification. This workmanlike approach to art appeals to John.

There was an additional factor that made the Lombardi commission attractive to him. John has always loved football, and played a great deal of the intramural and sandlot variety. So the chance to honor the great Vince Lombardi was to him an emotional challenge.

John will freely state that we are all bound by our personal styles, and he tends to think in vertical, rising curves. To him, Lombardi stood for work, inspiration, and determination, on the playing field and off. From this concept he began to visualize a vertical form that would have balance, grace, and stability. Then he began "thinking with his hands," as he so often does, and *Symbol of Courage* emerged as an upward spiral, an image of the search for ever greater achievement, but at the same time square, blocky, and with enormous vitality.

Several years later, John received a letter from a friend telling him that her daughter had cancer, and that as a result she had paid many visits to the Lombardi Clinic. She wrote that as she sat waiting for appointments, she was always able to draw some hope and inspiration from his sculpture. Nothing needs to be added to that.

One more sculpture is related in conception to *Challenge* and *Symbol of Courage*. In 1990, the retrospective NASM Trophy *Web of Space* was awarded to Kelly Johnson, the legendary head of the Lockheed Aircraft Corporation's famed Skunkworks, the secret area where Lockheed's most advanced projects were developed. Johnson, who died later in the same year, was one of the greatest aviation designers of all time, the genius who had led the teams that created the P-38 fighter, the Constellation, the U-2, and the SR 71 Blackbird.

Johnson had been too ill to come to the museum dinner to receive his trophy, so John wrote to tell him how pleased and honored he was to have his sculpture given to a man he had greatly admired for many years. As a young man he had joined the flying cadets, he said, with the dream of flying the P-38, because it was the most beautiful thing he had ever seen. A letter came back from Johnson's wife, explaining that her husband was too ill to speak, but that she had read John's letter to him several times, and each time he had smiled.

V Limits of Infinity

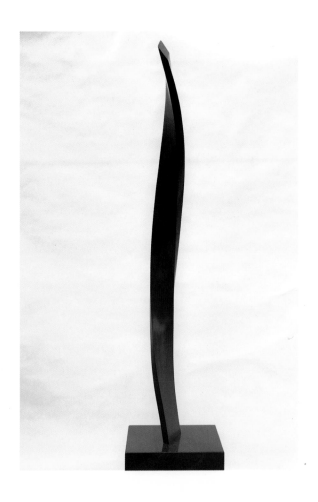

SEARCH (maquette) 1984 *Patinated bronze on black granite base, 13×4×4 inches.* *Collection of Dean John H.*
McArthur, Boston.

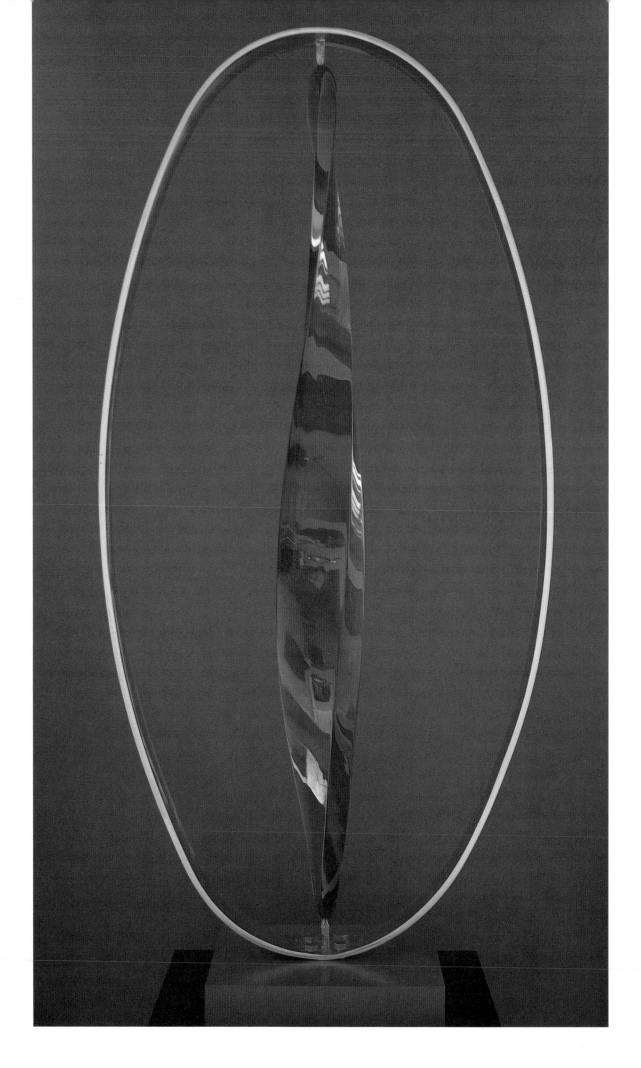

LIMITS OF INFINITY II 1976 *Brushed brass and brown Lucite on gray aluminum base, 68×16×16 inches.*

Collection of the artist, Washington, D.C.

One of John's most important works, in terms of both its artistic value and its impact on his career, is *Limits of Infinity I,* the sculpture that President Gerald Ford gave to King Juan Carlos of Spain in 1976.

This work, with its apparently self-contradictory title, inspires a veritable montage of flight images. In the *Limits of Infinity* design an airman sees myriad mechanical flight elements—a cowling, a gyroscope, a wing, a jet-engine intake, a shrouded fan. But more important, the work lyrically portrays the very essence of flight itself—an endless loop, a gut-twisting spin, an exhilarating corkscrew climb. This is an aviator's piece, without question.

The *Limits of Infinity* group of works developed through several stages. It began when John was carving a block of Lucite, with the intention of replicating an earlier work as an instructional process for a new studio assistant.

As he started to shape the Lucite, he found that he couldn't bring himself to repeat a previous sculpture. Instead, an original design began to grow, a three-dimensional version of the mathematical symbol for infinity. It was a graceful, delicate piece, made of misty gray Lucite.

When it was finished, however, John could not determine how to mount it. He tried a dozen different approaches, but was satisfied with none. Finally, he put it on the shelf and out of his mind.

LIMITS OF INFINITY II (detail)

Over the next year, an idea began growing in his mind involving a sculpture that would combine metal and Lucite. One day, as he was working on a totally different piece, the mounting solution for *Limits of Infinity I* came to him. He machined an elliptical ribbon of brushed stainless steel and mounted the Lucite sculpture within it. When he saw the infinity symbol totally enclosed, the title became self-evident.

Another stage in the development of the *Limits of Infinity* design came as a result of John's fondness for the works of James Whistler. Whistler had done a series of paintings that were studies of similar landscapes treated in different tones. From this John conceived the idea of approaching *Limits of Infinity* in the same way.

The initial version of the work had been in steel and gray Lucite, and very delicate. Safer began to plan a larger, more massive piece, to be executed in brown Lucite and burnished golden bronze; this became *Limits of Infinity II* (1976). Later, as I have noted, he was commissioned to do *Limits of Infinity III*, still larger and more massive, entirely in bronze, to be placed at a site in downtown Washington.

The presentation of *Limits of Infinity I* to the king of Spain by the president of the United States was, as might be expected, a major event in John Safer's career as an artist. After the presentation, there was a dinner in Juan Carlos's honor at the White House. Upon his arrival, John was introduced to the king by President Ford, who spoke of his sculpture in laudatory terms.

The king apparently did not share the President's enthusiasm. He greeted John formally, and gave him a quick nod and a brief handshake. John was a bit depressed, since he had been told that the king was a connoisseur of art, and he had hoped that his sculpture would be properly appreciated. Later, at dinner, a gentleman introduced himself to John as the ambassador to the United States from Spain. When he learned that John was the sculptor of the king's gift, he told him how enthusiastic Juan Carlos had been, adding that he must present John to the king after dinner.

John tried to explain to the ambassador that he feared the king's enthusiasm was all too mild, adding that he had already met him. The ambassador ignored these protests, and after dinner literally pulled him across the room, presenting him to the king, and explaining in Spanish who he was.

The king's face lit up, and he began to talk to John animatedly about the sculpture, in excellent English. It soon became obvious that although the king spoke English with ease, he did not understand it well, and had been unable to follow President Ford's relatively rapid phrases.

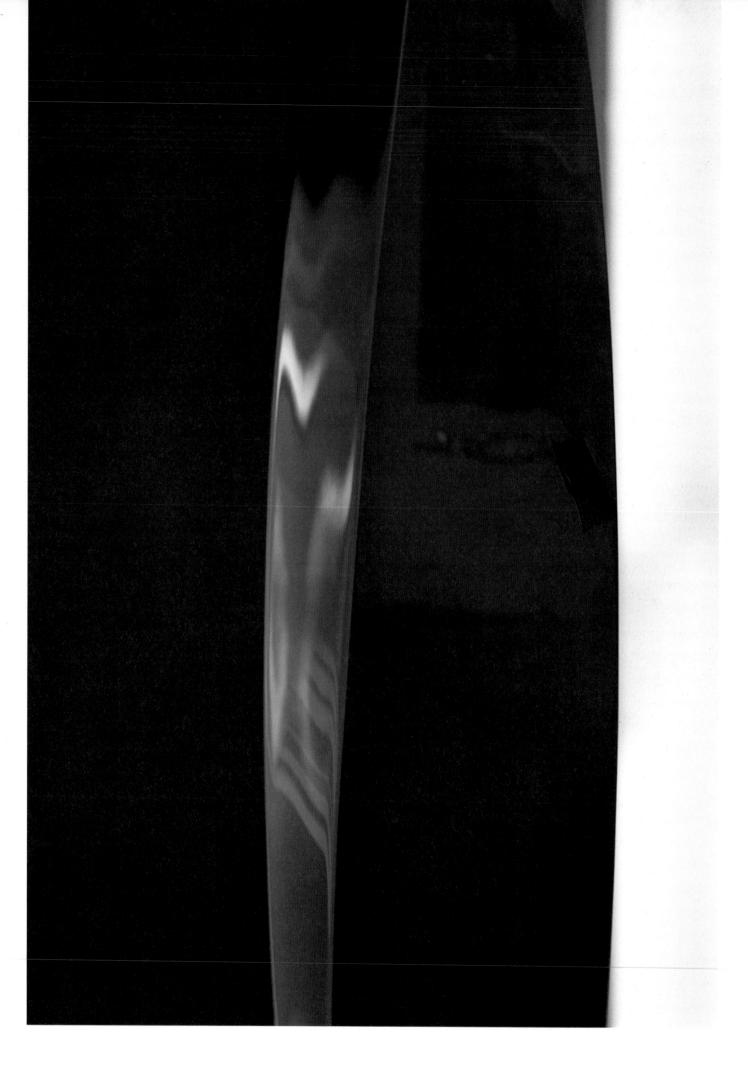

LIMITS OF INFINITY II (details)

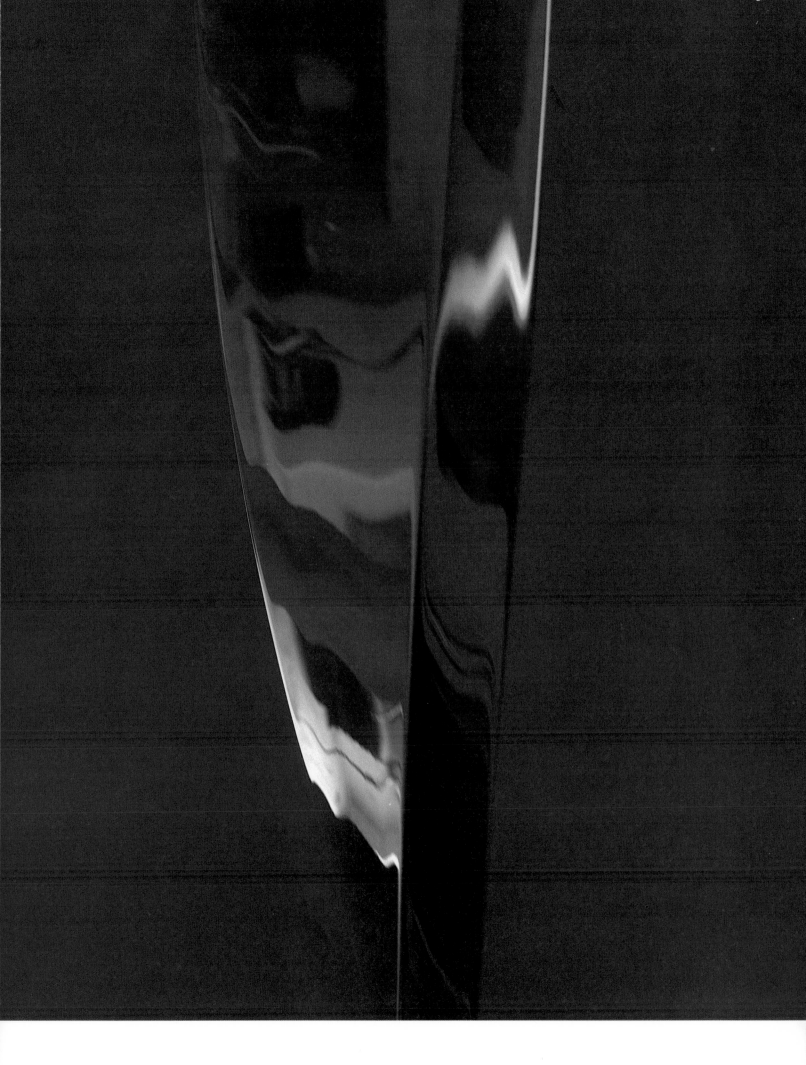

The recommendation to President Ford of John's sculpture had come from Henry Catto, then chief of protocol. Years later Catto became ambassador to Great Britain, and in 1989 he sponsored an exhibition of John's sculpture at the embassy in London to open its European tour. It was the second exhibition of John's sculpture there, the first having taken place in 1971 at the invitation of Walter Annenberg, who was the ambassador at that time as well as one of the world's great art collectors.

The 1989 exhibition took place in the embassy lobby, a great white marble area designed by Eero Saarinen. After the exhibition Ambassador Catto commented that he had never seen the lobby look so beautiful before, and probably never would again.

In 1983 John was approached by William Coleman, the former secretary of transportation. Coleman, a member of the board of the Chase Manhattan Bank, had just returned from a visit to Europe, where he and fellow board members had paid a state visit to the king of Spain, and had seen *Limits of Infinity I* in a reception room of the palace. Coleman said that he had told his friends, gathered around the sculpture, "Hey fellows, I know the guy who did this." One of the board members who had seemed most interested in the piece was John McArthur, dean of the Harvard Business School. Coleman pointed out to McArthur that John Safer was the sculptor who had created *Judgment* for the law school. McArthur responded that he knew *Judgment* and admired it, and wondered if Safer might be willing to do a work for the business school as well. Correspondence between John and McArthur followed. John was indeed interested in creating something for the business school, as he had a personal interest in the institution: his daughter, Janine, was at that very moment one of McArthur's students. The dean invited John to Boston to discuss the matter, and the result was a commission to create a sculpture to be placed in the center of the campus, where, among other events, the graduation ceremony takes place.

The sculpture John designed was the twenty-foot-high bronze *Search* (1984), inspired by his analysis of visual symbols of the business school. He began by rejecting the specific symbols of business and instead sought to identify and define for himself the essence of Harvard, possibly America's greatest teaching institution. He was able to summarize what he felt the school represented as "a question to which we have not yet found an answer."

To embody this abstract statement, he envisioned a curve groping up into space, a gestural shape that would give the sculpture the grace, balance, and beauty he always strives for. But at the top, the curve would be completely severed, cut off to symbolize the lack of completion and thus express the missing answer.

Search was designed, approved, and made ready for installation. Then a snag developed. The assistant dean in charge of administration did not wish to dig a hole in the

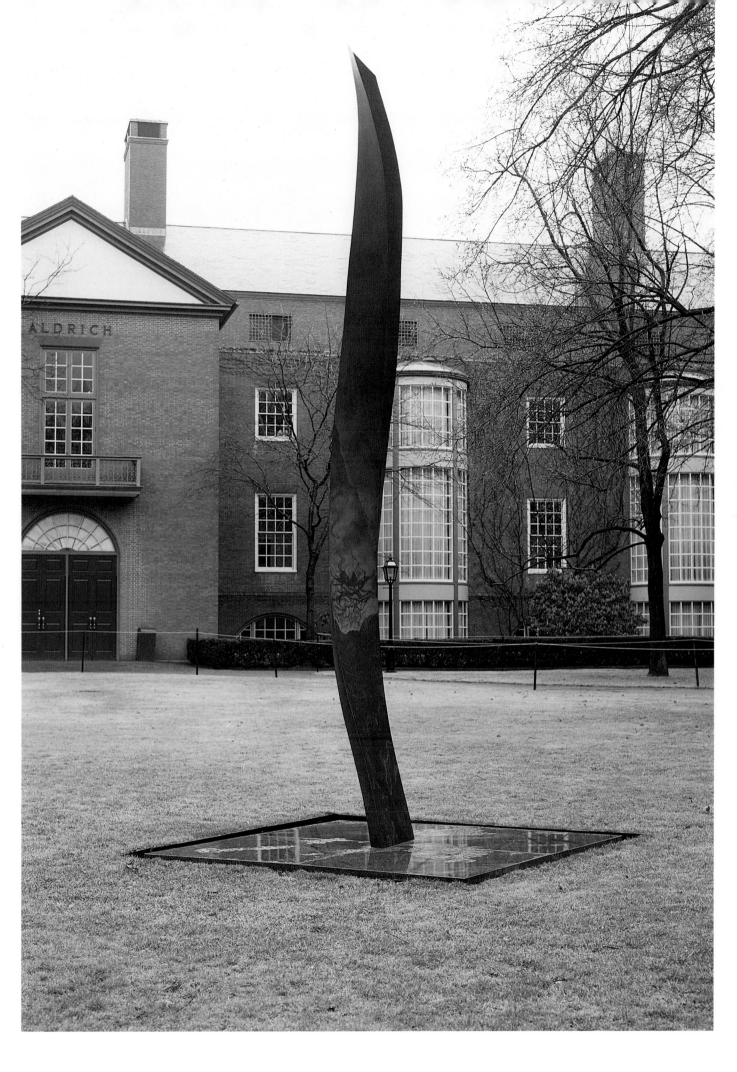

SEARCH 1984 *Patinated bronze on brown granite base, 20×3×3 feet.* *Collection of Harvard Business School, Boston.*

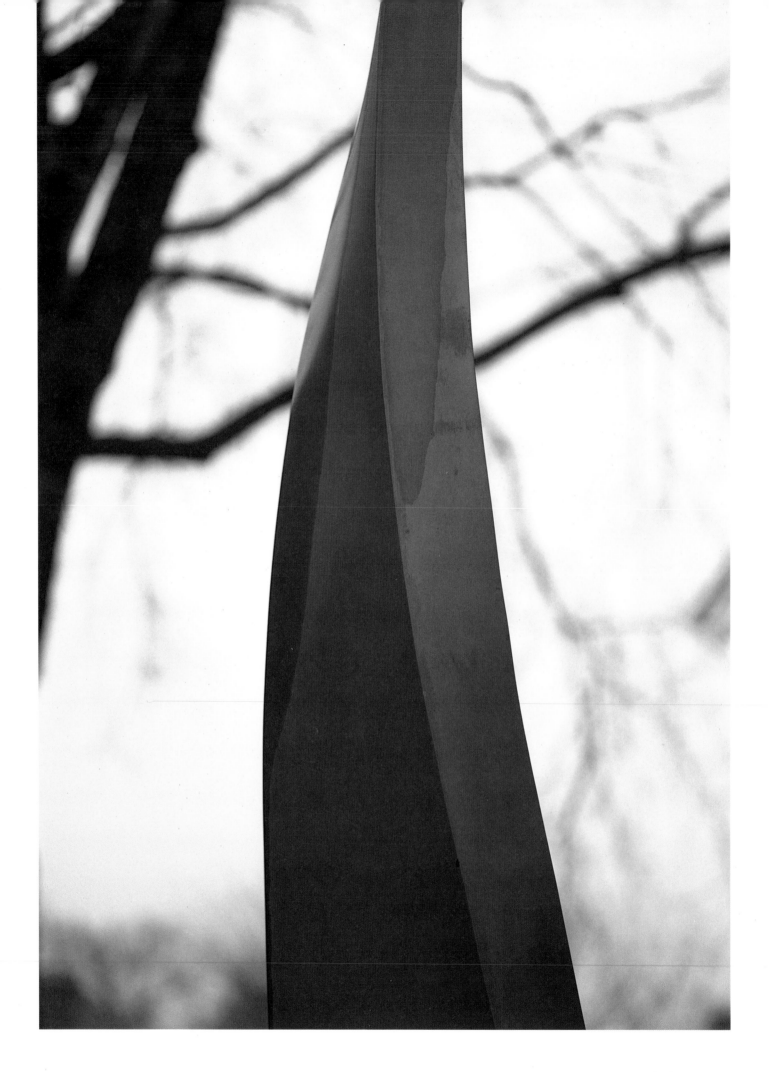

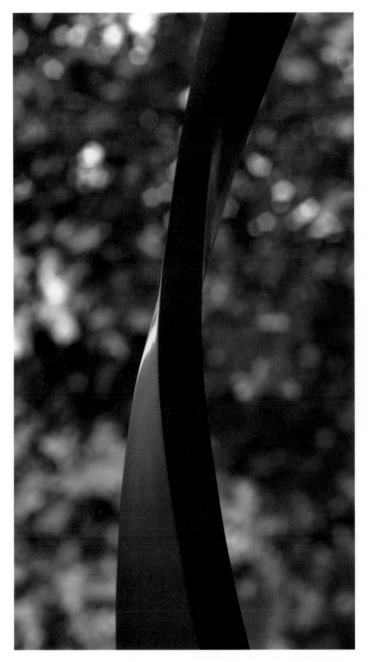
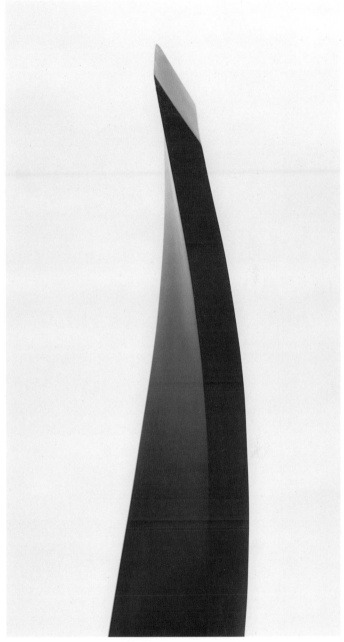

SEARCH (details)

1 3 5

center of the graduation area until after that year's ceremony. John, on the other hand, very much wanted the sculpture in place, because his daughter was in the graduating class. He argued and pleaded, but to no avail; the installation would have to wait until after graduation.

Then, ten days before graduation day, he received a call from the same assistant dean. It seemed that the speaker for the commencement ceremony was to be none other than King Juan Carlos of Spain. Dean McArthur had told the king that John had created a new sculpture for the business school, and had asked him to dedicate *Search*. The king had accepted the invitation, sparking a sudden panic: the sculpture had to be installed immediately.

Necessity is supposed to be the mother of invention. It may also be responsible for getting done in a few days what had previously been deemed impossible to do in many months. *Search* was installed on time, and John had the unforgettable experience of seeing his daughter graduate literally in the shadow of his sculpture.

VI Of Time and Space

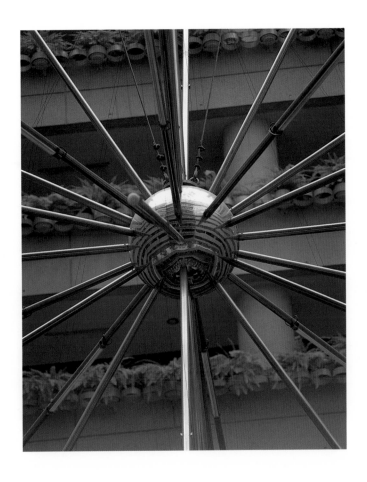

TIMEPIECE (detail) 1985 *Polished brass and bronze, bronze cable, neon tubes, incandescent bulbs, computer control center, 51×51×51 feet.* *Collection of the Oliver T. Carr Company, Washington, D.C.*

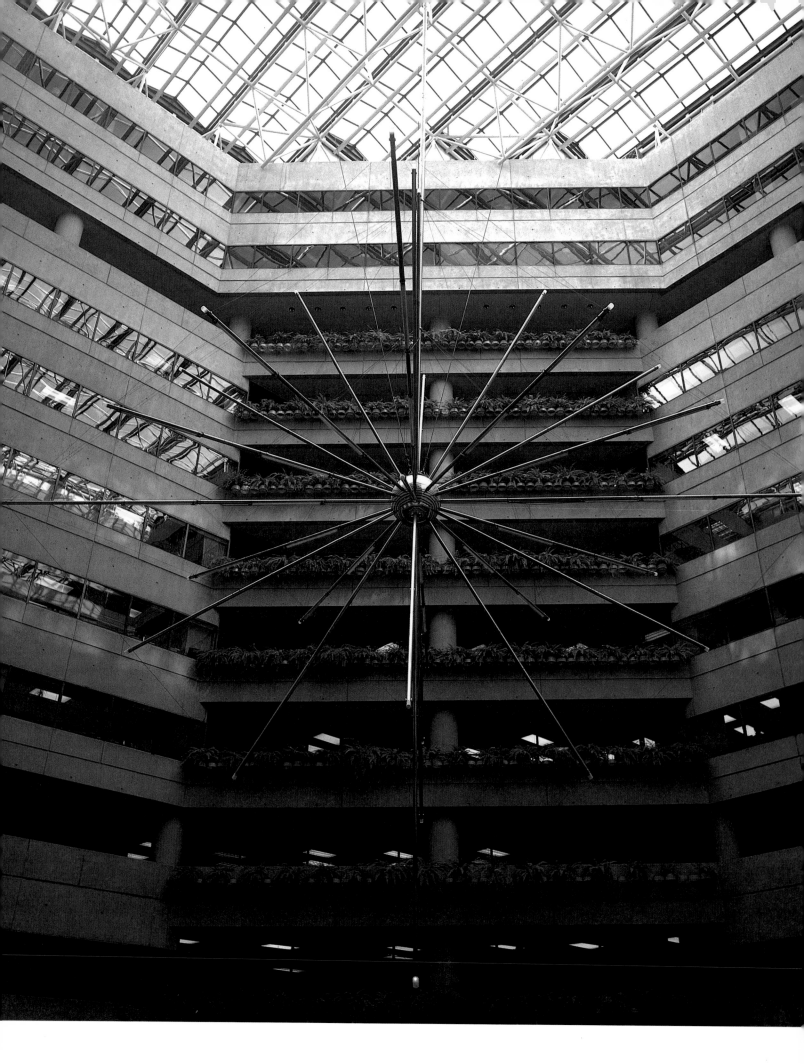

TIMEPIECE

The set of events that runs from the creation of *Limits of Infinity* to that of *Search* extends to *Timepiece* (1985), which placed John as one of the few sculptors in the *Guinness Book of World Records*.

Timepiece did not spring fully formed from John's imagination, as had many of his other sculptures. Its genesis was gradual, beginning with a request in 1983 from Oliver Carr, Washington's premier real-estate developer and the owner of the International Square Building there, for John, as one of a group of artists, to submit a design for a sculpture to be hung in the atrium of the building.

Normally John eschews competitions, because he does not believe that art and competition mix well. He made an exception in this case, since the atrium in question had caught his eye and imagination as one of Washington's great potential sites for sculpture.

Carr liked the model Safer submitted. However, after several months had passed, he was notified that the decision was to be made by a committee within Carr's company; while the committee members liked the model, they had decided that they wanted a kinetic sculpture.

A mobile that John designed in response was rejected, the process taking another six months. Somewhat dismayed, he was comforted to learn that while his models had not been approved, they had still been given higher ratings than any of the competing submissions. It was suggested that he meet with the committee and get its collective thoughts on the problem.

In this meeting he learned that the goal was a sculpture that would give the building a more human quality, and that would catch the eye of passersby, providing a focus of interest and conversation.

Years before, John had contemplated making a sculpture that was also a clock, telling time in a changing light display. He suggested to the committee that he create something in this vein, and received an immediate, unanimous positive response.

He went back to his studio, in no way surprised that his offhand suggestion had been approved. He feels that creativity works in mysterious ways, and that the committees that commission public art somehow sense this. By that evening he had a design in hand for a sculpture in brass, along with a general plan of operation and construction, for this project was to involve more than the fabrication of a sculpture; it had almost the complexity of a shuttle launch.

It took Safer a week to flesh out his concept, and a month to build a model, which won approval. There followed several months devoted to building a simplified working model, which was approved in its turn.

Then began the enormously complex construction task. John had to locate manufacturers who could fabricate the various parts—a major problem, since each element was unique. The exterior brass parts had to be polished and then coated so that the metal would not tarnish; as the piece was to hang sixty feet in the air, it could not later be repolished as casually as a hotel doorknob. The electronics had to be designed (the clock was to tell time by means of hundreds of lights working in a complex sequence), a wiring plan developed, and a suspension system to hold a multiple-ton device in midair worked out and integrated into the design of the sculpture.

In addition, a computer program had to be designed to control the multiple functions of the clock; a radio link had to be set up to tie the clock's computer to the National Bureau of Standards, so that it would always show the exact time; the levels of illumination had to be tested so that the time signals would be visible throughout the enormous lobby; and on and on.

After all this, the piece had to be assembled. The planning for this took more than six months. The sculpture was to occupy a spherical area over fifty feet in diameter, so it was not feasible to put it together in advance, but John rented a warehouse and had the parts laid out on the floor, so they could be wired and tested.

As this was taking place, he realized that *Timepiece* might be one of the larger clocks around. He turned to his friend Seth Atwood, who, at his Time Museum in Rockford,

TIMEPIECE (detail)

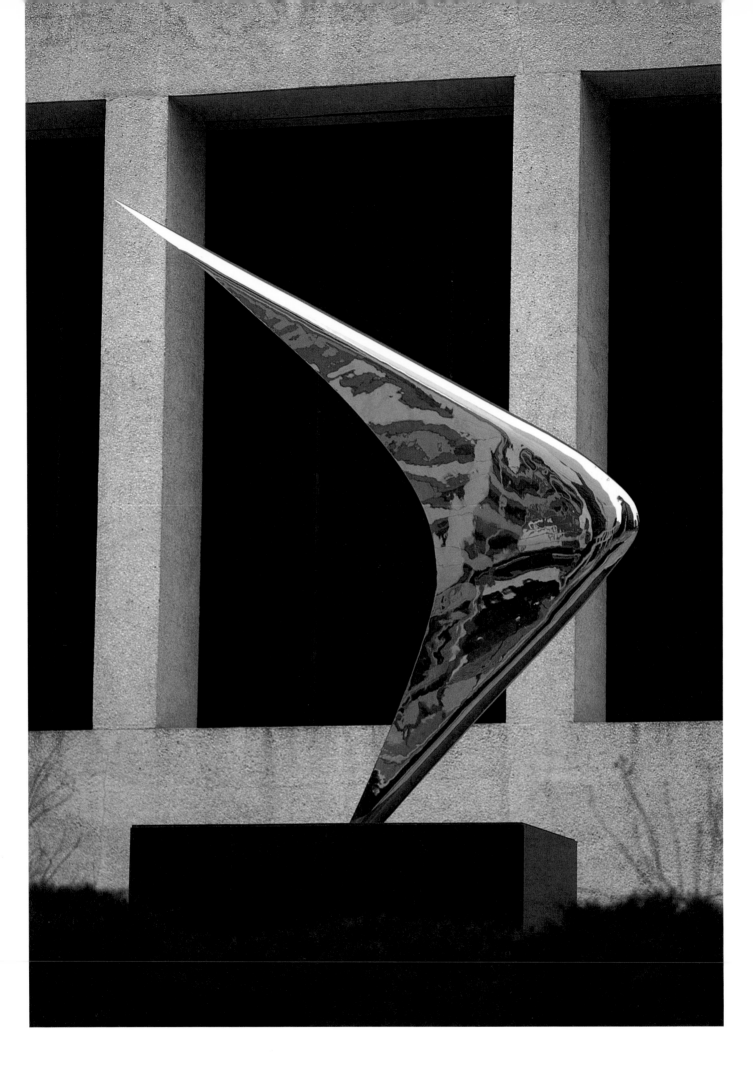

LEADING EDGE 1989 *Polished steel on black granite pedestal, 25×10×5 feet.* Collection of NationsBank,
Norfolk, Virginia.

Illinois, has the world's greatest collection of clocks and watches and is compiling a definitive encyclopedia on the subject. When John described *Timepiece* and asked where it would rank in comparison with other large clocks, he was told that it would be by far the largest clock in the world. *Timepiece* is today listed as such in the *Guinness Book of World Records*.

Finally, after two years of work, assembly of the piece began. The atrium in which the clock was to be installed extends below street level, and a scaffolding had to be built to support a temporary floor on which *Timepiece* could be assembled. There were offices, restaurants, and stores throughout the area, so work had to be done entirely at night.

First a one-ton brass ball, the center of the sculpture, was wheeled in. Then, slowly and carefully, all the arms, lights, and electrical connections that make up the piece were attached to it. While this was going on the sculpture was slowly hoisted toward the ceiling, and kept perfectly in balance as it rose. Around the face of the atrium's main balcony were installed the names of twelve places around the world, equidistant as one circles the globe. These place-names were lit, wired, and linked to the clock's computer, so that, as the earth turns each day, the position of the sun is indicated by the illumination of the appropriate spot.

The installation work took three months, from eight at night until four in the morning, and John says it was one of the most exhilarating experiences of his life.

When *Timepiece* was hanging free in the center of the atrium, he had the thrilling experience of throwing the switch and setting into motion not only the world's largest clock, but a sculpture of universal truth and import, one that clearly unites time, space, and light in a beautiful entity.

In 1984 John had been approached by his friends Norma Lee and Morton Funger, who had just acquired a sculpture by Henry Moore. *Reclining Woman* was a large outdoor bronze piece, and the Fungers sought John's advice on how to place it. He made some suggestions, and the Moore sculpture was appropriately sited. Over a year later he was pleased when the Fungers came to him with another request: that he create a companion piece for the Moore, to be placed in their garden.

John's response was the design for *Unity* (1987). *Unity* is a fourteen-foot-high sculpture of steel with a brushed surface, balanced on a reflective, polished black granite surface. It is composed of three slim, curving elements that seem to be gently moving reeds, so graceful that they become an expression of the very wind itself. Their lines, as fluid as ballerinas' hands, suggest growth, harmony, and oneness with nature—hence the title.

Shortly after this project, John began work on another major piece, one for which I have a particular fondness. *Leading Edge* (1989) is a bold and beautiful sculpture, and I accept some credit for its title.

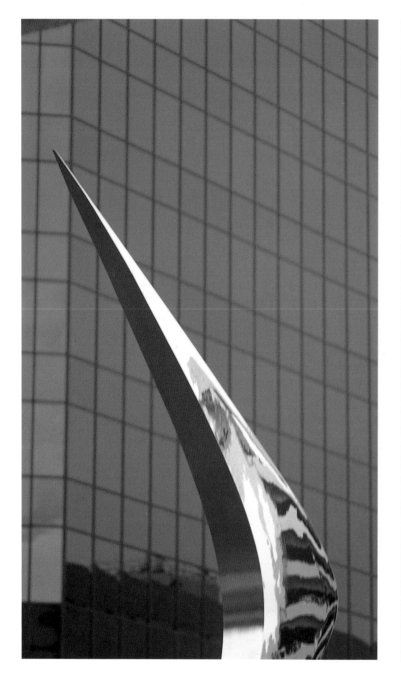
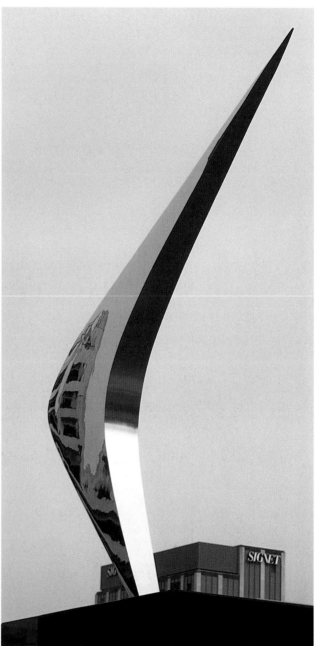

LEADING EDGE (with detail)

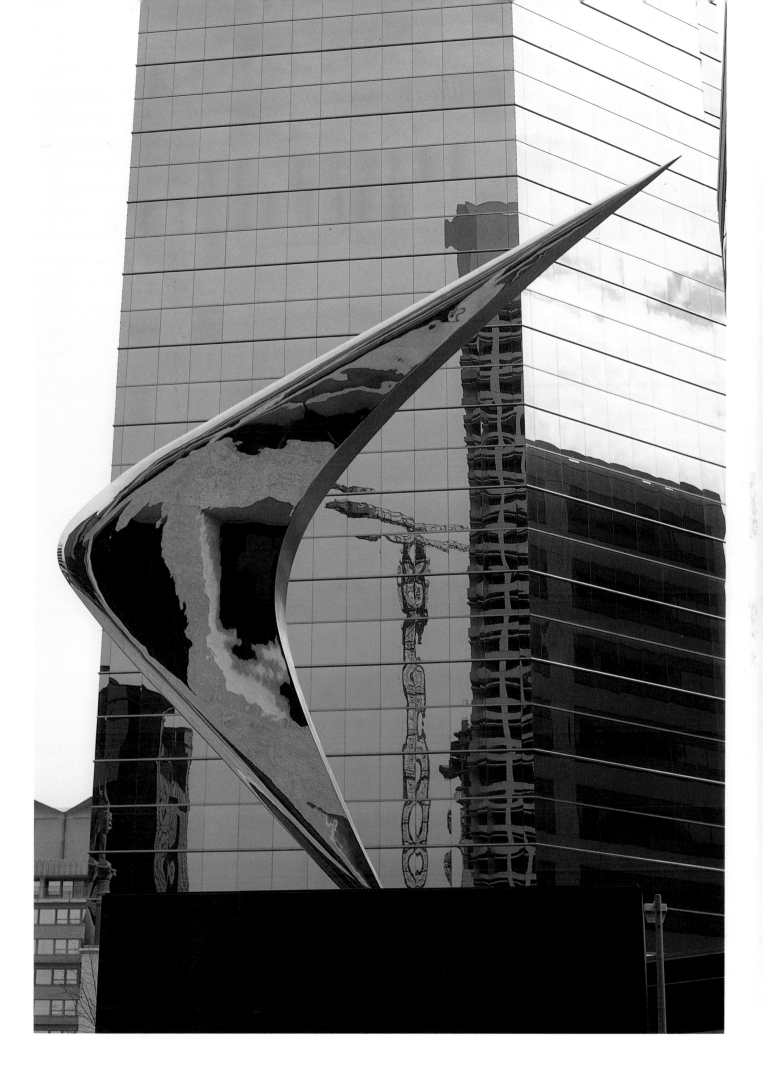

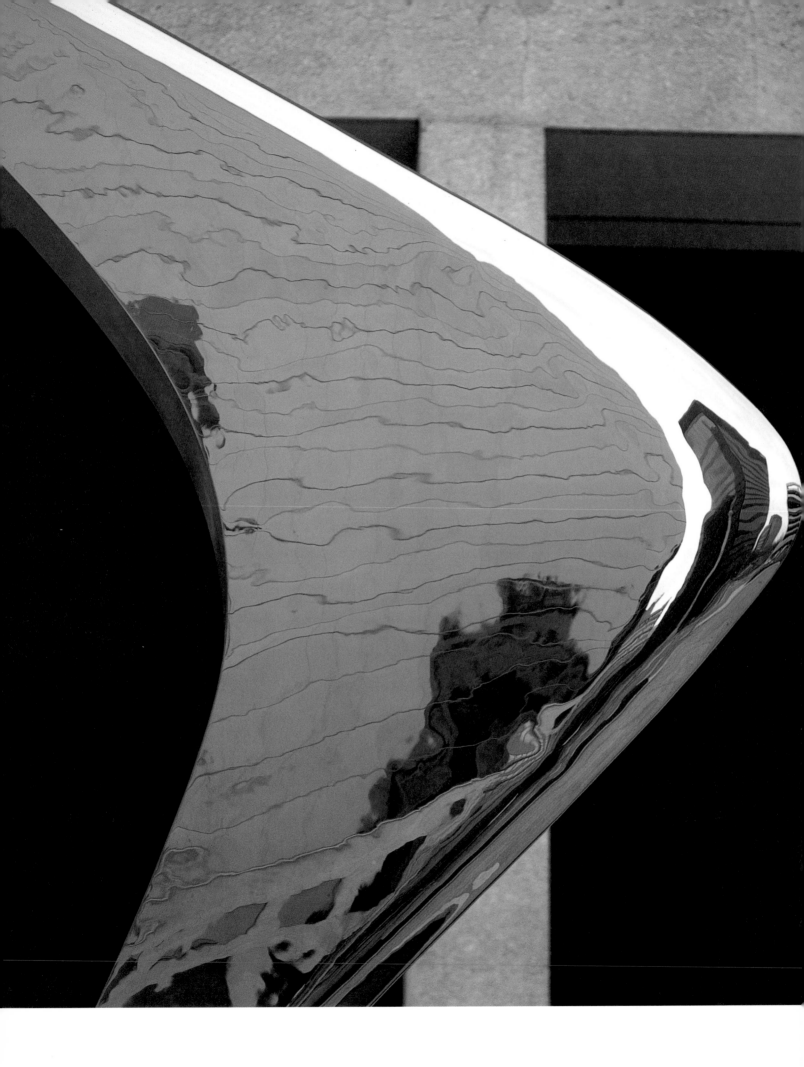

LEADING EDGE (detail)

In 1986 I published a book on aviation entitled *The Leading Edge*. Its essence was the history of those aviation devices—from a single element to a complete design—that extend the capability of an aircraft to its furthest limits. These limits may be of any sort—speed, altitude, range, maneuverability, safety, or some combination of these.

John liked the book, and immediately saw the link between its title and its central idea. We agreed that a similar book could be written about art; there have always been leading edges in art, some recognized on the spot, others languishing for decades before being perceived for their true worth.

Not very long after this, John was approached by Albert Gornto, who was about to become the chairman of the board and chief executive officer of Sovran Financial Corporation. Twenty years earlier, Gornto had been in charge of the construction of the structure that became the Sovran Center in Norfolk, Virginia.

He was exceedingly proud of the Sovran Center—not unexpectedly, since he had not only supervised its planning, but had devoted his life to the company headquartered there. From the start it had been planned that there would be a sculpture on the plaza in front of the building. The difficulty was that Gornto had never found a sculpture that satisfied him, one that he felt was worthy of adorning "his" building. As a noted sculptor who just happened to be on the Sovran board, John was a logical choice to create the missing work. Gornto asked him to attempt an appropriate sculpture for the empty plaza. He produced the design for *Leading Edge* in 1986, and Gornto knew that he had finally found the right image, one that aptly symbolized Sovran, the major banking institution in the region. The board concurred, and in 1989—for major sculptures take time to fabricate—*Leading Edge* was dedicated, to considerable acclaim.

The sculpture is a true leading edge, a wonderful, proud arc of shining, polished steel, rising twenty-five feet in the air on a black granite pedestal above a reflecting pool. Gornto liked it so well that he commissioned miniature *Leading Edge* sculptures for the offices of each of the chief executive officers of Sovran's banks.

Several months after the dedication ceremony, John had occasion to be in Norfolk, with an hour to kill before a meeting. A walk around the city led him inevitably to view his sculpture, standing like a sentinel outside the bank building.

He paused, experiencing one of those moments of comprehension that come so rarely. He looked across the plaza at the sculpture, planing upward to form a union in space with the Sovran Center building, and knew that were *Leading Edge* the only thing he had ever accomplished in his life, he would still feel fulfilled. I share his view.

UNITY (with details) 1987 *Brushed steel on black granite base, 14×12×12 feet. Collection of Mr. and Mrs. Morton Funger, Potomac, Maryland.*

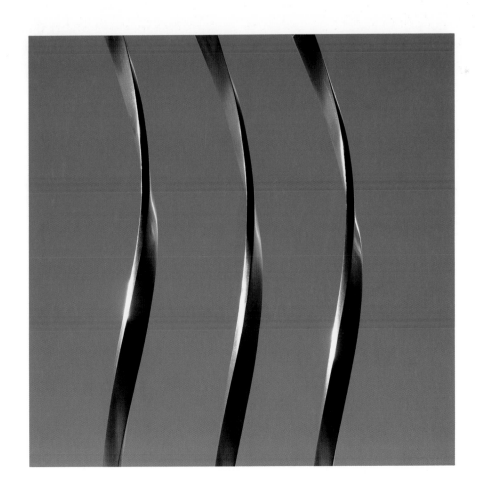

149

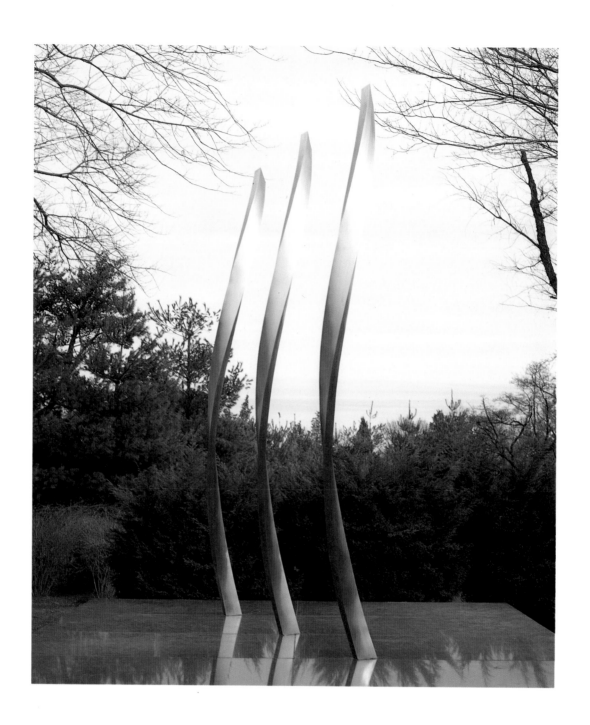

The final piece of John Safer's work that I wish to discuss is *Echo* (1983). I have placed it last because, along with *Web of Space*, it is my favorite. Two versions of *Echo* now exist. One is in John's collection, the other in the entrance to the Linville Ridge Country Club, in Linville, North Carolina, with a breathtaking panorama of the Great Smoky Mountains behind it. It seems to me that *Echo* is a perfect expression of the evanescent beauty of flight at altitude, its twin lines echoing contrails sparkling in a bright blue sky.

UNITY

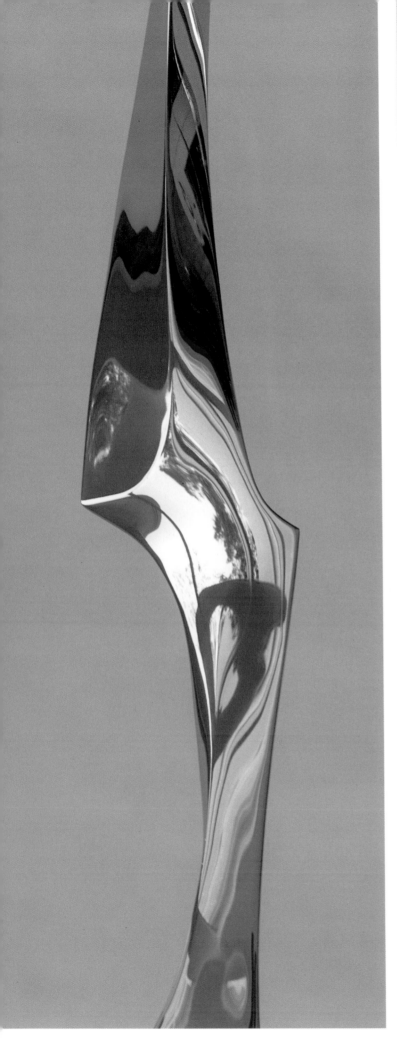
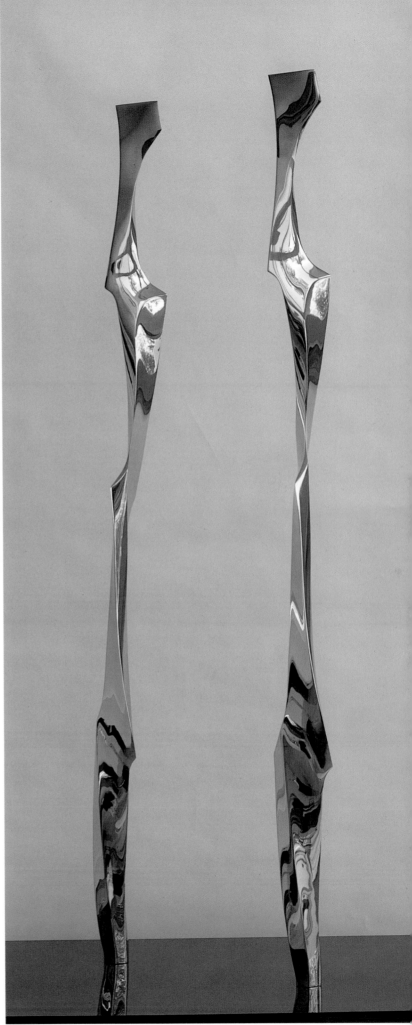

ECHO (with detail) 1983 *Polished bronze on black granite base, 9×4×3 feet.* Collection of Mr. and Mrs. Raymond Lutgert,

Linville, North Carolina.

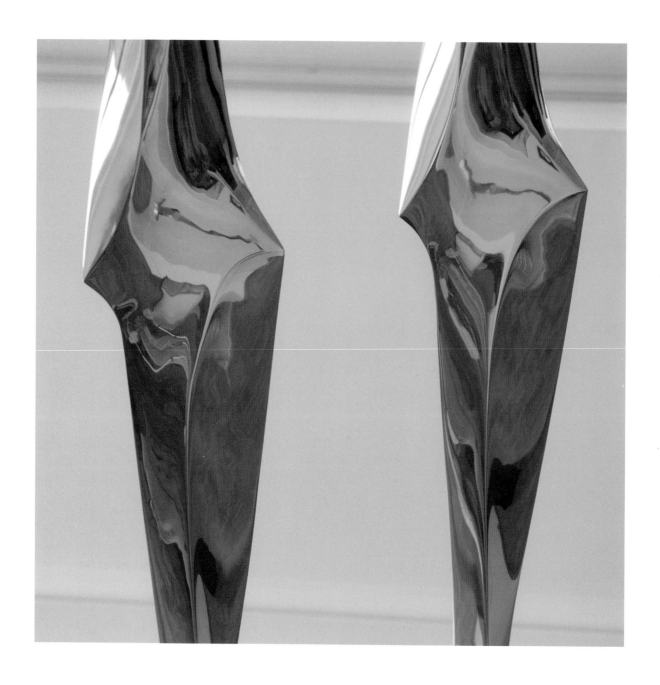

ECHO (detail)

VII A Final Thought

CHANDELLE (detail)

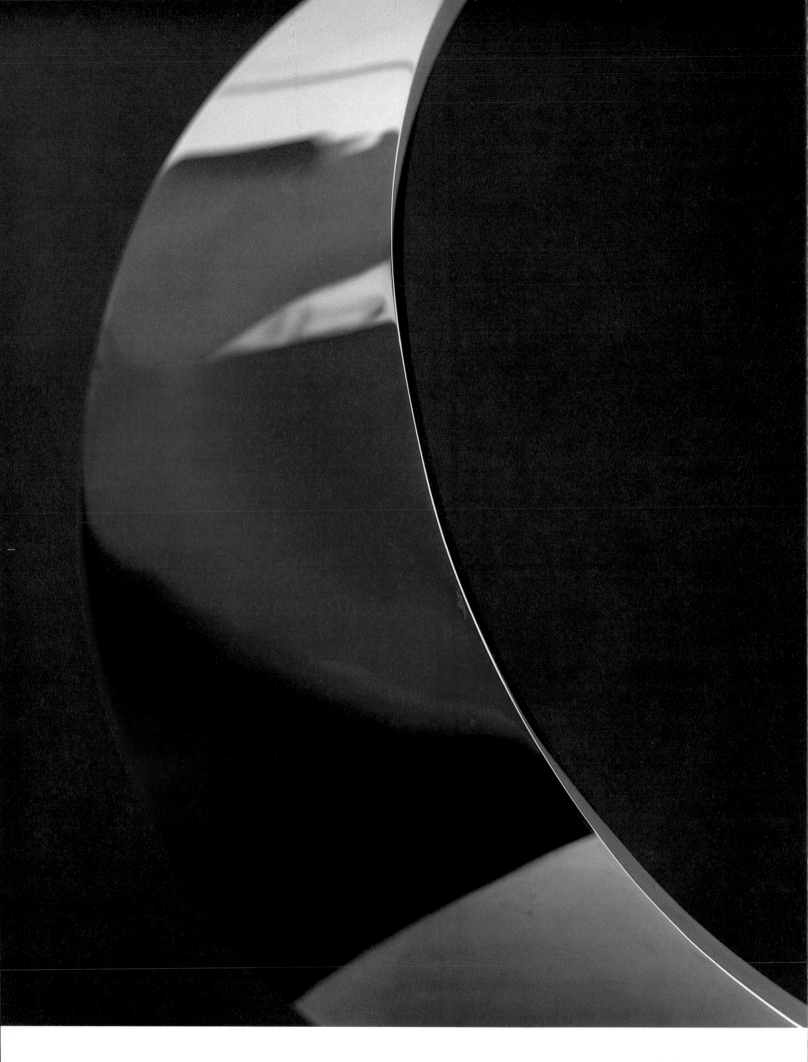

BEFORE THE WIND (detail)

In this brief, anecdotal overview of John Safer's work, we have seen the development of his talent and his vision from the early series of *Twist* sculptures to his current monumental works. In the process we have learned how much John demands of himself. He is tireless in the pursuit of his art, undaunted by challenge, and constantly seeking new horizons.

The most important result of these rigorous standards of performance is that they have created a basic internal harmony in his oeuvre. His sculptures seem to move to an ever-higher plane; they are rich with a sense of exploration and experiment; yet each remains instantly identifiable as a piece by John Safer. Even though he has used a wide variety of different materials and techniques, executed works in vastly different scales, and been inspired by infinitely varied themes, his work is united by far more than the remarkable beauty of each individual sculpture. Each piece has an integrity, implicit in its concept, explicit in its form, that reflects John's basic philosophy that life is good.

I attempted to elicit from John a forecast for his future work; he was reluctant to speculate, saying that he knew where he stood in relation to his universe, and that his goal was simply to become a little better.

And that is as desirable a forecast as anyone could wish. He is undoubtedly correct; he will become "a little better," steadily progressing from one new concept to the next, embracing new materials, accepting new challenges, all achievable because of his talent and dedication.

Biographical Note

I have mentioned John Safer's World War II service, his stint at Harvard Law School, and his subsequent careers in real estate and banking. In 1967 he became involved in national politics.

At that time John felt that the U.S. policies in Vietnam were leading us down a path to internal dissension and external disaster. This led him to attempt to persuade his friend Eugene McCarthy to run for the presidency on that issue. One night in September of that year, the two men sat talking in McCarthy's home. John advocated immediate action by McCarthy. At about eleven o'clock, McCarthy put out his hand and said, "All right, the McCarthy campaign for the presidency has just begun."

John directed the campaign until he was sidelined by a serious illness. Although the campaign was unsuccessful, its influence on subsequent U.S. policy was pronounced, and from this John derives great satisfaction.

John was married in 1950 and has two children, Janine and Tom. His marriage ended in divorce in the late 1970s, and he later married his present wife, Joy. In describing the decisions that have shaped his life, John tends to attribute the ones that did not work out well to poor judgment, and those that have led to successes to luck. He says that marrying Joy was the luckiest decision he has ever made.

Today Janine is Mrs. Jonathan Whitney, helping to operate a travel agency in New York and married to a partner in a major law firm, who specializes in banking. Tom and his wife, Annamarie, live in California, where he is a computer programmer.

Exhibition History

1969 Michael Berger Gallery, Pittsburgh

1970 Glade Gallery, New Orleans

Pyramid Gallery, Washington, D.C.

1971 Westmoreland County Museum of Art, Greensburg, Pennsylvania

New York Cultural Center, New York

United States Embassy, London

Valley House Gallery, Dallas

Alley Gallery, Houston

1972 Montclair Art Museum, New Jersey

1974 United States Embassy, Lisbon

United States Cultural Center, Brussels

United States Embassy, Bucharest

Beethovenhalle, Bonn

1975 David Findlay Galleries, New York

1977 Hokin Gallery, Palm Beach, Florida

1978 High Museum of Art, Atlanta

David Findlay Galleries, New York

1984 Cheekwood Fine Arts Center, Nashville

Hunter Museum of Art, Chattanooga

Dulin Gallery of Art, Knoxville

Mint Museum of Art, Charlotte

1985 Norton Gallery of Art, Palm Beach, Florida

Harmon-Meek Gallery, Naples, Florida

National Air and Space Museum, Washington, D.C.

1986 United States Embassy, Nassau, Bahamas

1989 United States Embassy, London

Espace Pierre Cardin, Paris

1990 United States Embassy, Bern

United States Cultural Center, Brussels

Public Collections

American Hospital, Paris

Baltimore Museum of Art

C&S/Sovran Corporation, Norfolk, Virginia

Celanese Corporation, New York

Corcoran Gallery of Art, Washington, D.C.

Cosmos Club, Washington, D.C.

First American Bank of Maryland, Silver Spring

FitzGerald Tennis Center, Washington, D.C.

General Mills, Minneapolis

Georgetown University Hospital, Washington, D.C.

Golf Hall of Fame, Pinehurst, North Carolina

Harvard Business School, Boston

Harvard Law School, Cambridge, Massachusetts

High Museum of Art, Atlanta

Milwaukee Museum of Art

National Air and Space Museum, Washington, D.C.

National Peace Institute Foundation, Washington, D.C.

Philadelphia Museum of Art

Ponce Museum of Art, Ponce, Puerto Rico

Project Hope, Middleburg, Virginia

Royal Collection of Spain, Madrid

San Francisco Museum of Art

United States Embassy, Beijing

United States Embassy, Bern

United States Embassy, Brussels

United States Embassy, London

Venezuelan National Museum, Caracas

Williams College, Williamstown, Massachusetts

Index

Photograph Credits